Lyrics : Édith Piaf ▪ Music : Louiguy, 194?

Des yeux qui font baisser les miens,
Un rir' qui se perd sur sa bouch',
Voilà le portrait sans retouch'
De l'homme auquel j'appartiens.

Refrain {

Quand il me prend dans ses bras,
Qu'il me parle tout bas,
Je vois la vie en rose.
Il me dit des mots d'amour,
Des mots de tous les jours,
Et ça m' fait quelque chose.
Il est entré dans mon cœur
Une part de bonheur
Dont je connais la cause.
C'est lui pour moi,
Moi pour lui, dans la vie,
Il me l'a dit, l'a juré pour la vie.
Et, dès que je l'aperçois,
Alors je sens en moi
Mon cœur qui bat.

Des nuits d'amour à plus finir
Un grand bonheur qui prend sa place,
Les ennuis, les chagrins s'effacent.
Heureux, heureux à en mourir.

Refrain

great french songs

The publishers would like to thank the following
persons for their invaluable contribution:
Alexis Gregory, François Siegel, Pierre-Denis Leroyer,
Jean-Louis Rancurel (collector), Jean-Michel Tomé (collector),
André Bernard (collector), Solange Khaled of the INA,
Sophie Renaud and Darius Shepard of Archive Photos, Monsieur Marchois of
the Association des Amis d'Édith Piaf, Madame Keiko Nakamura of Infini in Japan,
Monsieur Lallemand of Éditions Paul Beusher, Madame Francis Lemarque,
Sylvain Lebel, Hortense Bataille, Anne Dechanet, and Mathilde Guinot.

Chapter-title illustrations:
pages 8–9: Édith Piaf
pages 34–35: Édith Piaf and Les Compagnons de la Chanson
at the Gare Saint-Lazare, Paris
pages 58–59: Charles Trenet in the film *Je Chante*
pages 80–81: Charles Aznavour
pages 97–98: Yves Montand at the Étoile in 1963

Designer: Louise Brody
Executive editor: Catherine Laulhère-Vigneau
Editor: Émmanuelle Laudon

Photogravure: Dela Plus, Paris

Copyright © 1997 Éditions Plume / Adès, Paris
Translation copyright © 1997 The Vendome Press, New York

Published in the USA in 1997 by
The Vendome Press
1370 Avenue of the Americas
New York, NY 10019

Distributed in the USA and Canada by
Rizzoli International Publications
through St. Martin's Press
175 Fifth Avenue
New York, NY 10010

Library of Congress Cataloging-in-Publication Data
Delanoë, Pierre.
Great French songs : La vie en rose and other hits /
by Pierre Delanoë.
p. cm.
ISBN 0-86565-993-1
1. Popular music—France—History and criticism. I. Title.
ML3489.D45 1997
782.42164'0944—dc21
97-15237
CIP
MN
Printed and bound in Italy

great french songs

la vie en rose and other hits

Text by Pierre Delanoë

Captions by Alain Poulanges

the vendome press

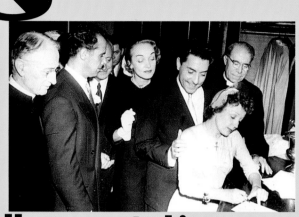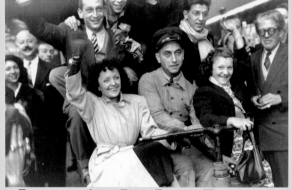

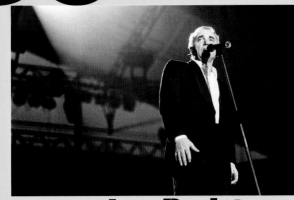
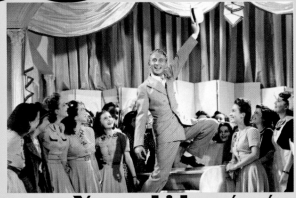

I n writing this book, I've wanted not to speak of myself but rather to share with you my old love affair with the French song. I was weaned and nourished on this art, thanks to my mother, who sang from morning till night as she went about her business: sewing dresses. Moreover, I was born at the same time as radio and records, which allowed me to hear all the great stars of the period— Maurice Chevalier, Mistinguett, Marie Dubas, Dranem, and Georgius—as well as the operettas of Christiné, Maurice Yvain, and Vincent Scotto: in other words, everything that was produced between the wars, from 1918 to 1939. I was in the prime of my youth when I first heard that clarion call known as Charles Trenet and found myself overcome by the charm of Mireille. I made the most of this flowering, a cultural revolution comparable to the yé-yé or pop wave that would roll over us a quarter of a century later. Why call it a revolution? Because Trenet and Jean Johain, the lyricist for Mireille as well as my godfather at the SACEM, brought to popular song precisely what it lacked: poetry. Aristide Bruant, forty years earlier, had been a poet, but he never ventured beyond the world of petty criminals, beggars, jails, and the streets of Montmartre, which, though colorful, limited his lyrical range.

With Trenet and Nohain, song burst forth from lungs filled with spring air. Rhythm, imported from the United States by Maurice Chevalier, woke up and routed the old music droning away in two- or three-four time. *Y a d'la joie, Je chante, Un petit chemin,* and *Couchés dans le foin, J'ai ta main. . . .* With such titles one could narrate an entire history, a story as luminous as a face smiling with love. Their colors did much to brighten the dark, sinister years of the German Occupation. Hearing them, we could forget, for a brief moment or two, the shame of our defeat.

Can you imagine a world in which birds, trees, and springs had been silenced and music suppressed? When the publisher asked me to write this book, I began right away to celebrate: *"Quand un vicomte rencontre un autre vicomte / Q'est-ce-qu'ils se racontent? Des histoires de vicomtes."* Now let me take you on a tour of my musical domain, a place with dozens of flower beds planted or invented by composer/poets. As Pierre Perret once said: *"Vous saurez tout tout tout sur la zizique."* And to learn everything *la zizique* ("music") has to teach, you have only to sing along with our book in hand. The lessons, alas, will have to be selective, given the wealth of material produced by French writers and composers. Each, in the form of a chapter, will bear the title of a song, just as the book itself is subtitled *La Vie en rose.*

Meanwhile, can you guess the first subject to be explored? *L'amour,* of course.

Pierre Delanoë in 1960 with Gilbert Bécaud [1] and in 1955 during a party at the Juan-les-Pins home of Félix Marouani [2], who, with his brother Daniel, was one of the foremost impresarios in French theatre. Opposite: Gilbert Bécaud.

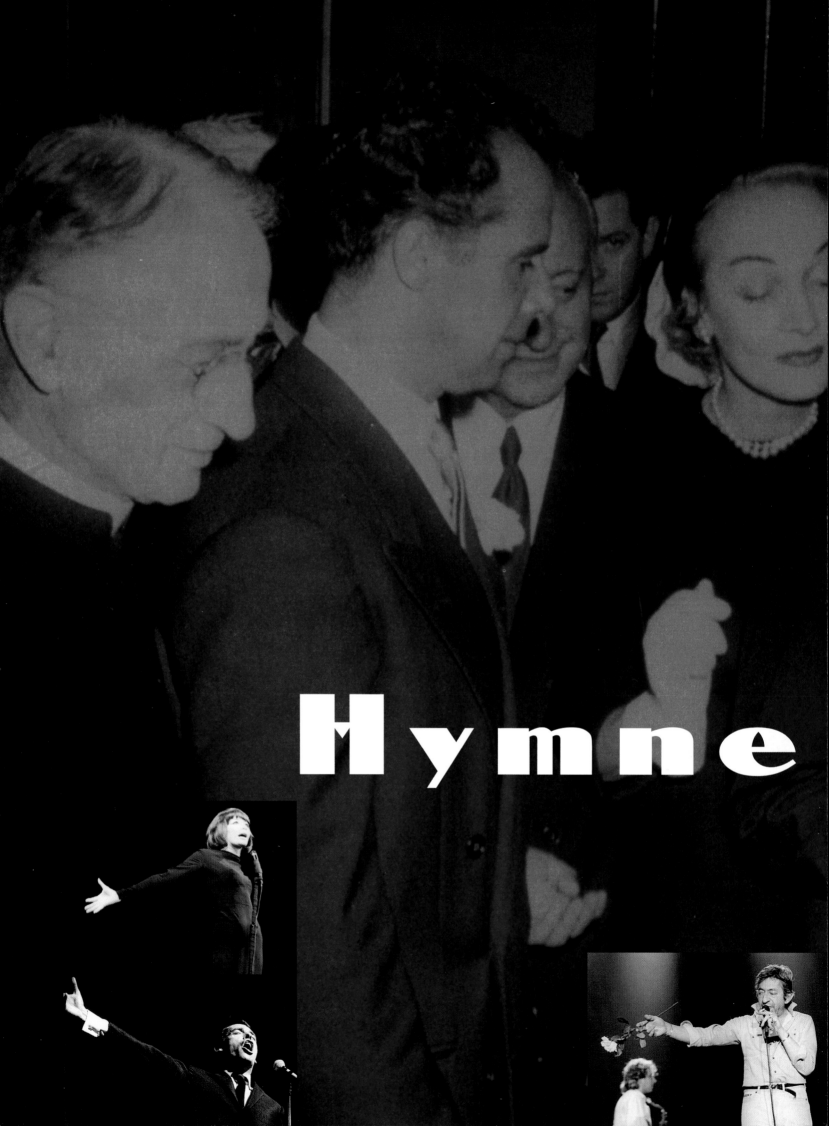

Hymne

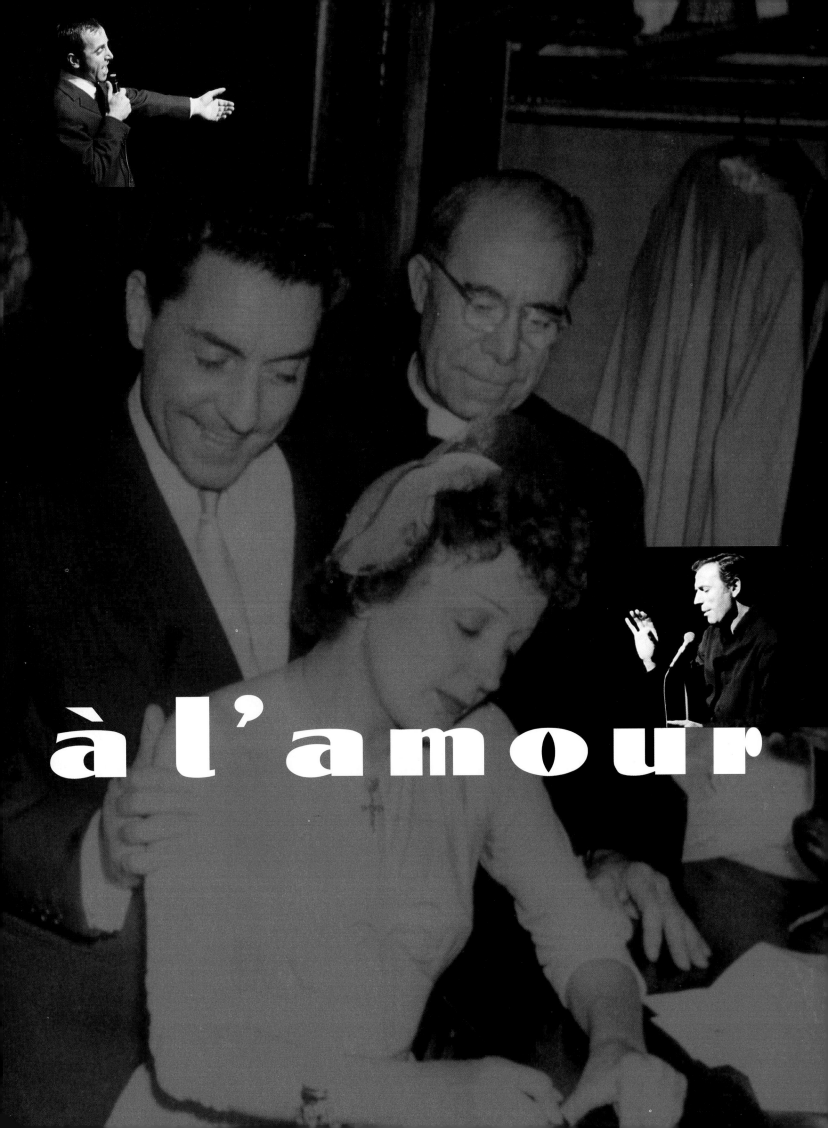

à l'amour

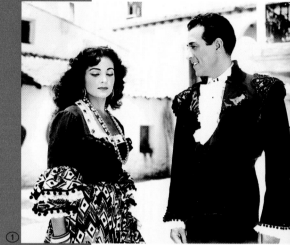

①

②

*L*a *Belle de Cadix* was born on Christmas night in 1945. Premiered at the Théâtre du Casino Montparnasse in Paris, it was scheduled to run for six weeks, only to become a smash hit. Following a tour of France, which lasted until 1948, Luis Mariano revived the show two years later at Paris's Théâtre de l'Empire. In 1953, Raymond Bernard brought Luis Mariano and Carmen Miranda together for the last time in a film adaptation, which proved somewhat disappointing, given the great success of the operetta [1]. Tino Rossi (here [2] with Simone Valère in Richard Pottier's *Deux Amours* of 1948) fared much better on the screen than did Mariano. In his very first movie, *Marinella* (1936), Rossi established himself at the forefront of the new generation of romantic singers. Blessed with a body as well as a voice, he scored with every appearance before the camera, despite questionable talents as an actor.

he trouble with *l'amour*—that most indispensable of French nouns—is its want of good rhymes, since words like *tambour*, *topinambour* (Jerusalem artichoke), and *vautour* (vulture!) hold little promise for the subject. Luckily, there are always *secours, jour, bonjour*, and a few others. And so the key phrases become *je t'aime, tu m'aimes, on s'aime*—those endless declarations of love conjugated from past to future tense. Sovereign clichés all, which I've done my best to avoid, having no wish to write yet more *chansons d'amour*. As a result, *Mes mains, Et maintenant*, and *Je reviens te chercher* figure among my best known songs, but no *je t'aime*. This is not to say that I have anything against *l'amour*, which remains one of the most resonant words in the language. Moreover, it's hard to imagine anything more beautiful than the phrase *je t'aime*.

Brassens wrote little on the subject, Brel considerably more: *Ne me quitte pas, Ce soir j'attends Madeleine*, and, best of all, *Quand on a que l'amour*. For a true champion, however, the love song must look to Charles Aznavour, especially in his *Sur ma vie, Les Plaisirs démodés, L'Amour c'est comme un jour*. . . .

The first song anyone ever writes is almost invariably a love song. Not only is the theme the most popular imaginable; it is also the easiest to develop, in virtually every culture. The English, Italian, and Spanish repertoires abound in *I love you, Ti amo*, and *Yo te quiero*. The biggest French successes—*Comme d'habitude (My Way), Les Feuilles mortes (Autumn Leaves), Un Homme et une femme*,

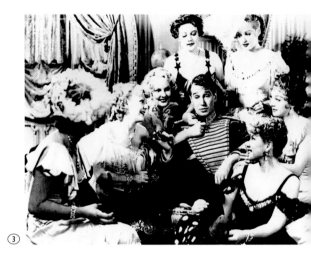

③

Lyrics : Édith Piaf ▪ **Music** : Marguerite Monnot, 1949

Le ciel bleu sur nous peut s'effondrer
Et la terre peut bien s'écrouler
Peu m'importe si tu m'aimes
Je me fous du monde entier
Tant qu'l'amour inondra mes matins
Tant que mon corps frémira sous tes mains
Peu m'importe les problèmes
Mon amour puisque tu m'aimes
J'irais jusqu'au bout du monde
Je me ferais teindre en blonde
Si tu me le demandais
J'irais décrocher la lune
J'irais voler la fortune
Si tu me le demandais
Je renierais ma patrie
Je renierais mes amis
Si tu me le demandais
On peut bien rire de moi
Je ferais n'importe quoi
Si tu me le demandais
Si un jour la vie t'arrache à moi
Si tu meurs, que tu sois loin de moi
Peu m'importe si tu m'aimes
Car moi je mourrais aussi
Nous aurons pour nous l'éternité
Dans le bleu de toute l'immensité
Dans le ciel plus de problèmes
Mon amour crois-tu qu'on s'aime
Dieu réunit ceux qui s'aiment.

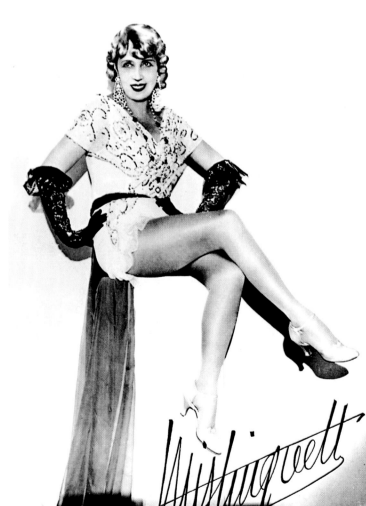

Music hall generated its own "hymns to love." The one involving Mistinguett [4] and Maurice Chevalier [3] is legendary. She, the inaccessible star, spotted the promising beginner and gave him a chance at the Folies-Bergères. Together they made a perfect couple: "We spoke the same language, that of the working classes." If La Miss did not create Chevalier, she certainly helped him break into the opulent, extravagant theatre of the 1910s. He went on to become an international star, achieving a truly fabulous career. On stage Chevalier radiated *l'esprit parisien*, while on the screen he emerged as the "French lover" par excellence.

④

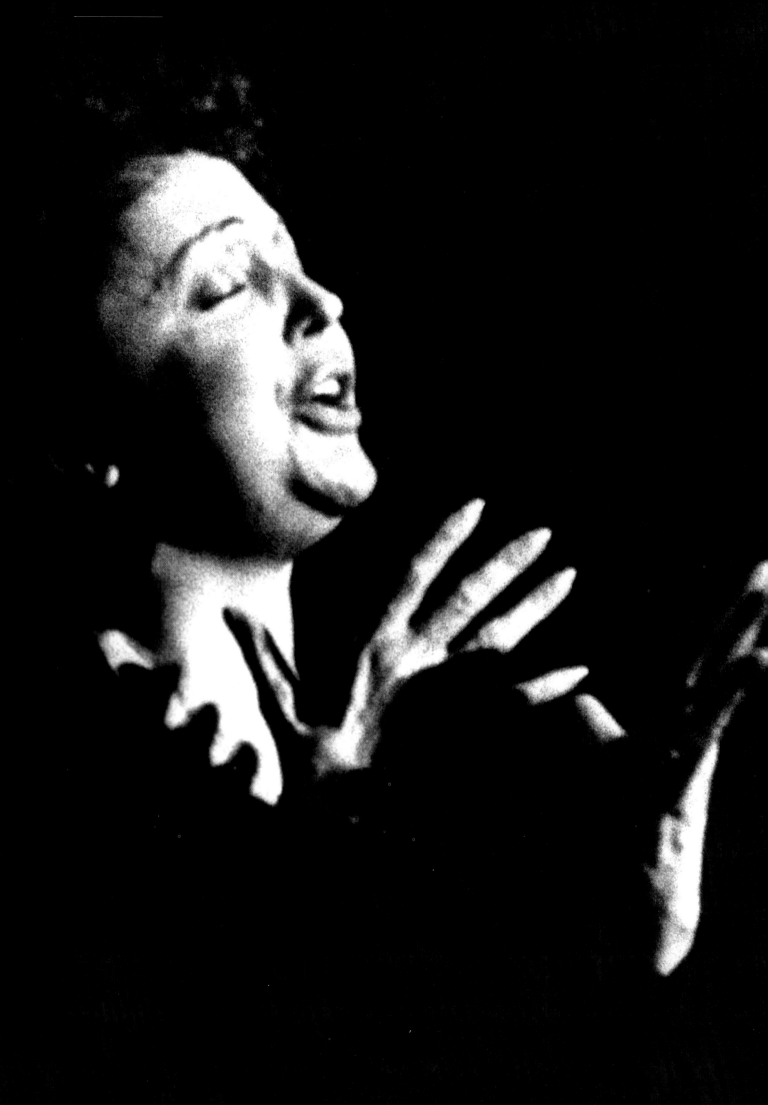

It's the people who choose the voices they identify with. Most often the voices are those of the street. Édith Piaf [1]—born 19 December 1915 on a sidewalk in Paris's 19th arrondissement (Belleville/Ménilmontant), to a singer and an itinerant acrobat—led an existence translated, almost literally, from realist song. Along the way, Piaf endowed the pathetic with nobility, bringing tears to the eyes of several generations, as much by her life as by her art.

Tino Rossi [2], one of eight children born to a Corsican tailor, departed early for his conquest of the mainland. Within a few years his golden voice—that blend of velvet, milk, and honey—won him the status of a living myth. His romantic songs caused many a heart to flutter, and nothing could stop him, neither fashion, nor age, nor even a growing paunch.

Maurice Chevalier [3] first saw the light of day on 12 September 1888 in Ménilmontant. From an impoverished and difficult childhood he drew the strength to make his mark on the entire world. A child of the people, Chevalier began performing at the age of twelve and never stopped, always fearful he might end up where he had started.

or *La Vie on rose*—are all love songs, numbers hummed throughout the world. What's more, *La Vie on rose* is everywhere sung in French! A first love song can always be indulged, but subsequent attempts deserve a more critical hearing, to make sure they reveal a true gift. Talent, of course, is rare, and banalities in plentiful supply.

Can you name the first *chanson d'amour* to appear in modern times? *Plaisir d'amour*, written in the eighteenth century by the fabulist Florian, a grand nephew of Voltaire, and set to music by Martini. It is still one of the most beautiful of all love songs. A classic of more recent times is *Parlez-moi d'amour*, which Lucienne Boyer made a tremendous hit in the United States.

While writing this I've noticed that the adapters of my song *Et maintenant* have translated the title as *What Now, My Love?*, thereby introducing the word for *amour!* A chapter dealing with love songs could go on forever, because, inevitably, love crops up in almost every song, a kind of art that is nothing more than a reflection of life itself. And where there is life, there is love—or that variant called hatred. The songs sung by Édith Piaf are essentially a cry for love: *L'Hymne à l'amour, La Vie en rose, Mon Dieu, Mon légionnaire, L'Accordéoniste, C'est à Hambourg, Les Amants*, etc., etc. She often wrote them herself; most of all, she lived them. Piaf deserves the Oscar of the century. Alongside the passionate, "lived" style, emotions carried to the point of paroxysm, there exist all sorts of romantic numbers, from mellow, sweet ballads such as Mireille's *Un Petit chemin* or

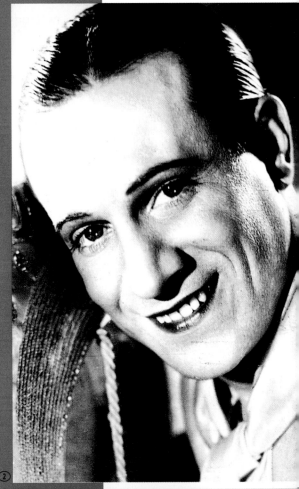

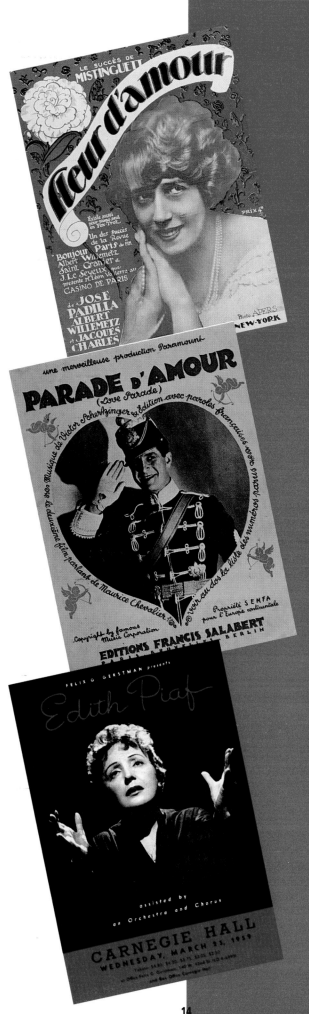

Couchés dans le foin and Trenet's *J'ai ta main* to the Corsican cooing of Tino Rossi in *Tchi Tchi, Ce soir Nina,* and *Vieni vieni* or the tenorial flights of Luis Mariano (*La Belle de Cadix*).

A great popular song lasts forever, a number for all seasons. Brel wrote one in *Ne me quitte pas,* Aznavour in *Que c'est triste Venise,* Bécaud in *Le Mur,* Nougaro in *Une petite fille en pleurs,* Barbara in *Pierre,* Hallyday in *Que je t'aime,* or Sardou in *Je vais t'aimer.* Separation, longing, regret, remorse, revenge, despair—all have given rise to thousands of songs: Polnareff's *Je ne veux pas vivre,* Chevalier's *Je ne veux pas vivre sans amour,* Claude François's *Le Téléphone pleure,* Brel's *Jef,* Moustaki's *Sarah,* and so forth.

On the other hand, there is happy, springtime, impulsive love, with birds chirping, flowers in bloom, a little white wine in the glass, and accordions all around. Here we have *Pour un flirt* (Michel Delpech), *Mademoiselle Lise* (Bécaud), *Margot* (Brassens), *Emmène-moi danser* (Michèle Torr), *Les Filles de mon pays* (Macias), *Femme* (Lama), *Fleur de papillons* (Annie Cordy). . . .

"My love, I shall adore you forever, to the end of time"—add a few notes of music and off we go. On the other hand: *"Je t'offrirai des perles de pluie / Venues de pays où il ne pleut pas,"* or *"Et la mer efface sur le sable les pas des amants désunis";* or yet *"Elle court la maladie d'amour."* These texts will endure, because their authors had talent, grace, and luck. Unfortunately, those who write don't always consider whether they have the right stuff. There are as many love songs as there are lovers—as there are lives. A song is not always a love story, but a love story is always a song.

Before the advent of radio and records, songs circulated in small formats—sheet music. Sheets like those illustrated at left were sold in the streets by strolling singers. At street corners, in marketplaces, the accordionist and the vocalist gave renditions of the latest numbers before audiences of idlers "making the rounds." Publishing houses provided the necessary passage on the road to success. At the beginning of the 1930s Paris could boast some 300 publishers, all more or less situated in the Faubourg Saint-Martin. Here writers and composers came together and made common cause. *Les Feuilles mortes* is one of the rare songs born of music already composed, in this case by Joseph Kosma for a ballet by Roland Petit, *Le Rendez-Vous.* Jacques Prévert then wrote the lyrics. Cora Vaucaire was the first to record the piece, against the advice of her producers, who found both words and music too intellectual. Yves Montand, then Juliette Gréco, Tino Rossi, and many others made it their own. In the United States, *Les Feuilles mortes* became *Autumn Leaves,* as well as a hit, thanks to renditions by Frank Sinatra, Nat King Cole, and Miles Davis. In 1930 Lucienne Boyer won the grand prize for her record of a song by Jean Lenoir, *Parlez-moi d'amour.* A classic, it pursued Boyer to the end of her days, until finally, in response to demands for encore after encore, she responded: *"Parlez-moi d'autre chose."*

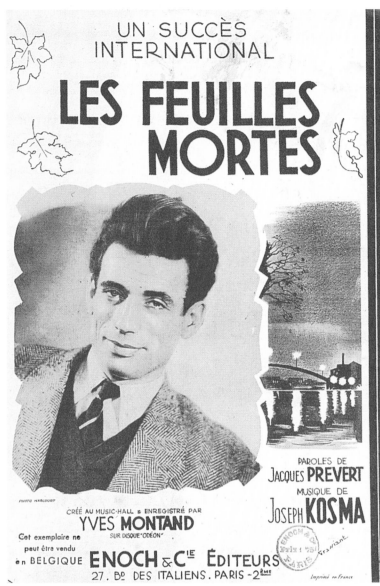

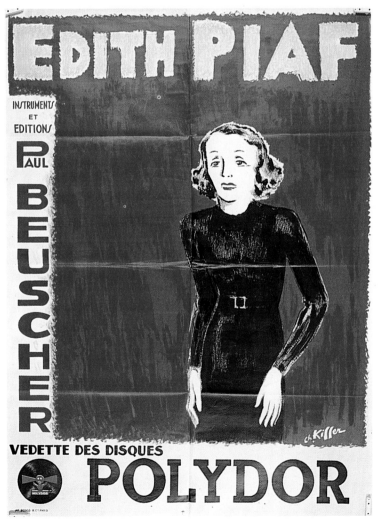

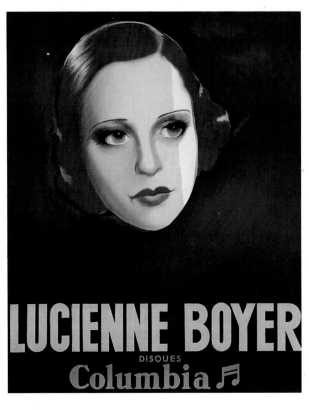

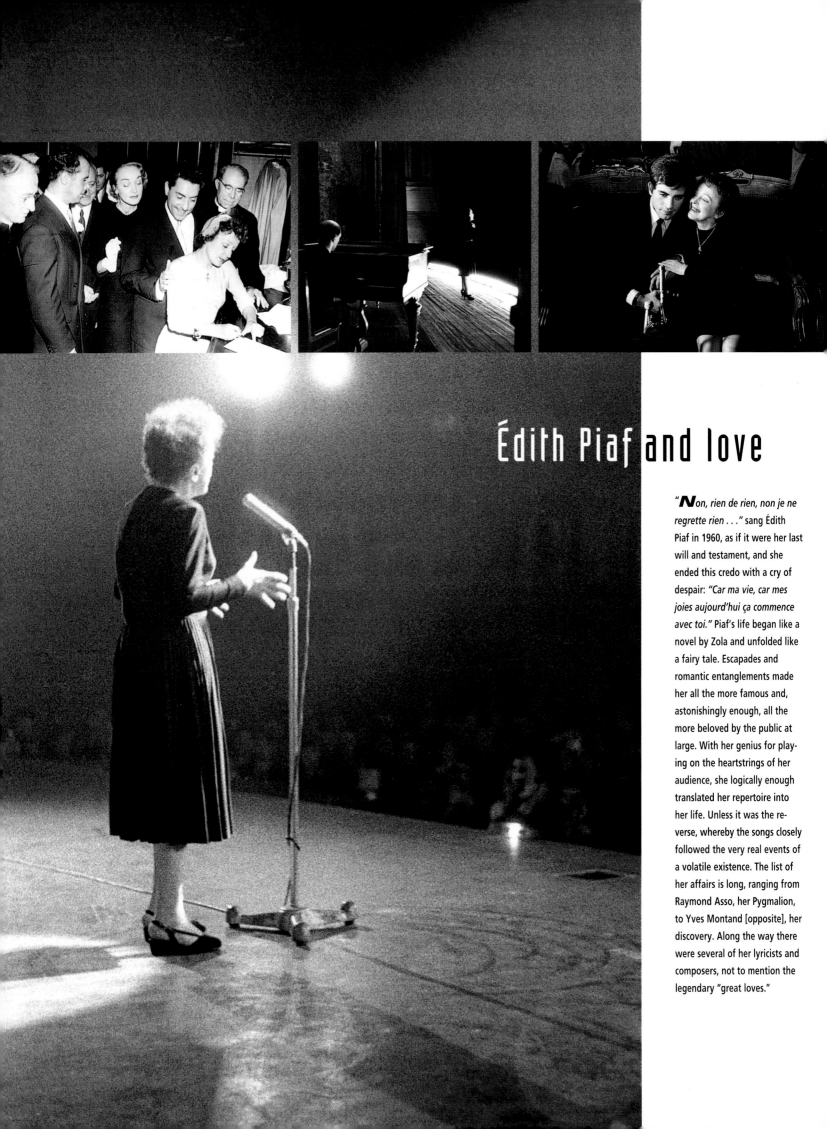

Édith Piaf and love

"**N**on, rien de rien, non je ne regrette rien . . ." sang Édith Piaf in 1960, as if it were her last will and testament, and she ended this credo with a cry of despair: "*Car ma vie, car mes joies aujourd'hui ça commence avec toi.*" Piaf's life began like a novel by Zola and unfolded like a fairy tale. Escapades and romantic entanglements made her all the more famous and, astonishingly enough, all the more beloved by the public at large. With her genius for playing on the heartstrings of her audience, she logically enough translated her repertoire into her life. Unless it was the reverse, whereby the songs closely followed the very real events of a volatile existence. The list of her affairs is long, ranging from Raymond Asso, her Pygmalion, to Yves Montand [opposite], her discovery. Along the way there were several of her lyricists and composers, not to mention the legendary "great loves."

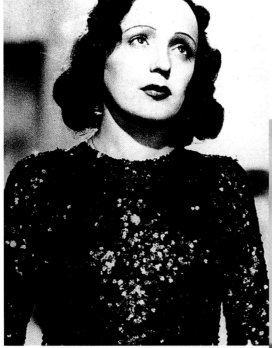

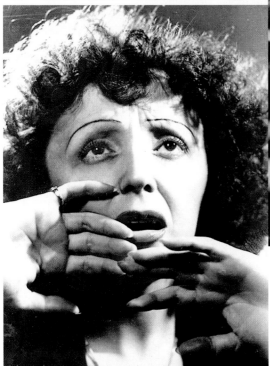

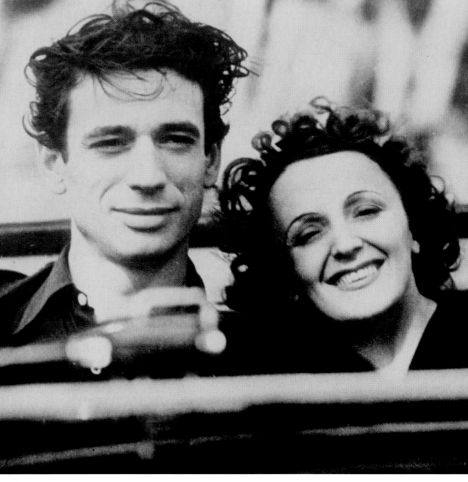

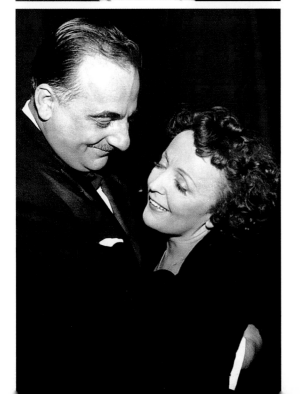

Piaf's involvement with the great French boxer Marcel Cerdan, a married man with children, garnered no backlash from the public, which, on the contrary, viewed the relationship as a magical encounter of two particularly brilliant stars. After Cerdan perished in an airplane crash, Piaf wrote *Hymne à l'amour*. In 1953, in New york, she married Jacques Pills with Marlene Dietrich as a witness [opposite, above left]. More and more ravaged by drugs and illness, Piaf collapsed in 1959 during a recital in Mau-beuge. Still, she soldiered on, living only for the theatre and for love. She survived three hepatatic comas, continuing to perform before a public always hopeful of being present at the final death blow. In 1962 she married a very young man of Greek origin, Théo Sarapo [opposite, above right]. With Théo, Piaf returned to the Olympia stage, at the request of her friend, Bruno Coquatrix [left, below]. Together, they created *À quoi ça sert l'amour?*, a song by Michel Émer which finishes with these words:
"Mais oui! Regarde-moi!
À chaque fois j'y crois!
Et j'y croirai toujours . . .
Ça sert à ça, l'amour!"

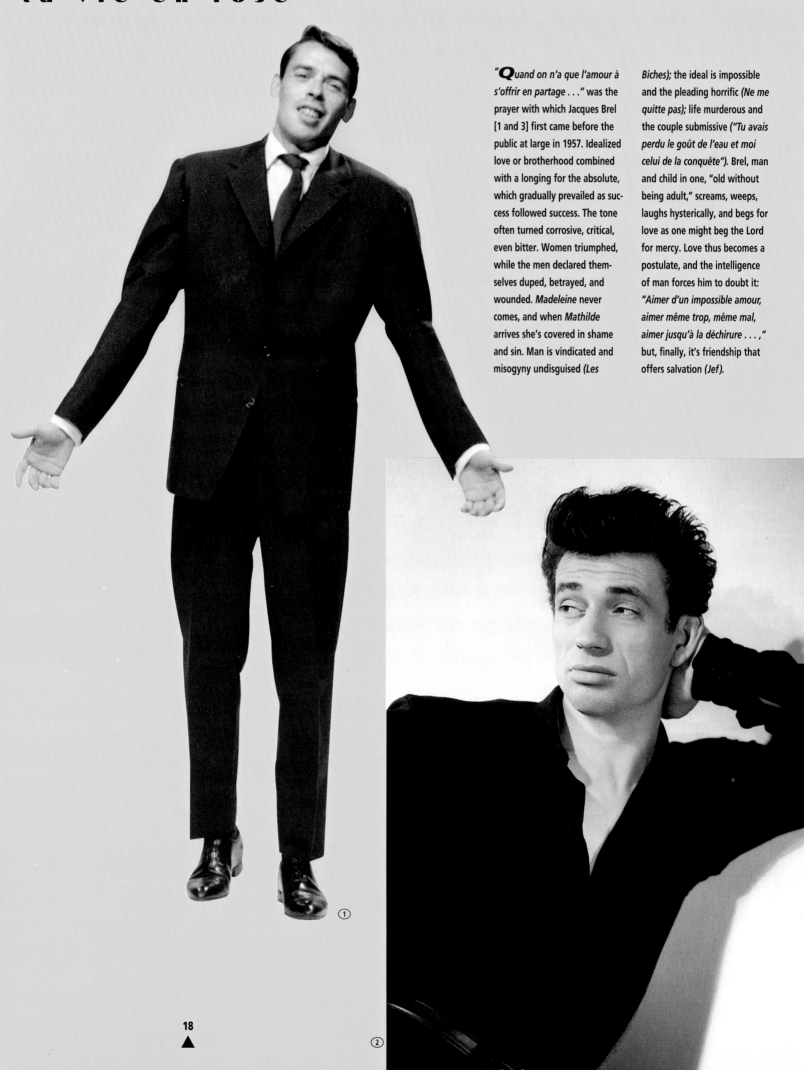

"*Quand on n'a que l'amour à s'offrir en partage . . .*" was the prayer with which Jacques Brel [1 and 3] first came before the public at large in 1957. Idealized love or brotherhood combined with a longing for the absolute, which gradually prevailed as success followed success. The tone often turned corrosive, critical, even bitter. Women triumphed, while the men declared themselves duped, betrayed, and wounded. *Madeleine* never comes, and when *Mathilde* arrives she's covered in shame and sin. Man is vindicated and misogyny undisguised (*Les Biches*); the ideal is impossible and the pleading horrific (*Ne me quitte pas*); life murderous and the couple submissive ("*Tu avais perdu le goût de l'eau et moi celui de la conquête*"). Brel, man and child in one, "old without being adult," screams, weeps, laughs hysterically, and begs for love as one might beg the Lord for mercy. Love thus becomes a postulate, and the intelligence of man forces him to doubt it: "*Aimer d'un impossible amour, aimer même trop, même mal, aimer jusqu'à la déchirure . . . ,*" but, finally, it's friendship that offers salvation (*Jef*).

18

① ②

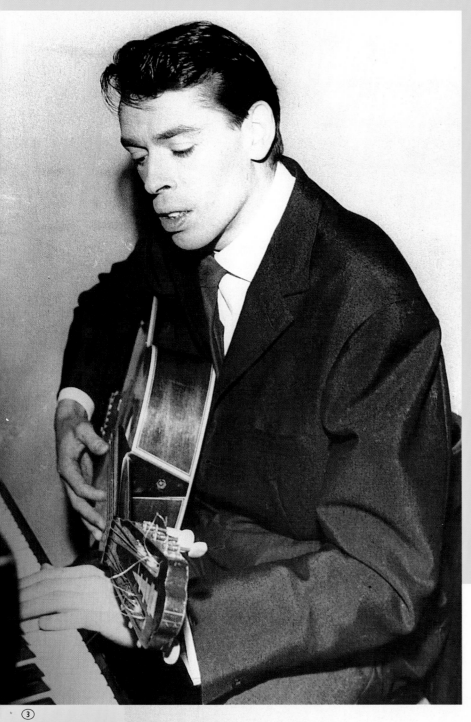

"**R**omance pops up at the foot of the bed in the person of this big, alive young man, this boyish, sharp and virile, tender and funny guy who calls himself Yves Montand . . . ," wrote Jacques Prévert. Together, Montand and Prévert gave the love song some of its brightest moments. The poetic genius and velvet voice of a dazzling performer combined to make the public's heart throb as never before. Montand [2 and 4]—the aristocrat of the streets raised to stardom by women, spoiled with love, and forgiven for being a born seducer. Montand, a hardworking man of the theatre, left nothing to chance. Tirelessly striving for perfection, he betrayed his fear of letting himself go. Montand, the man, owed his success to determination as well as to charm. In the end, Montand found himself respected and honored, a joyous condition he bore with grace and a full appreciation of the power it bestowed.

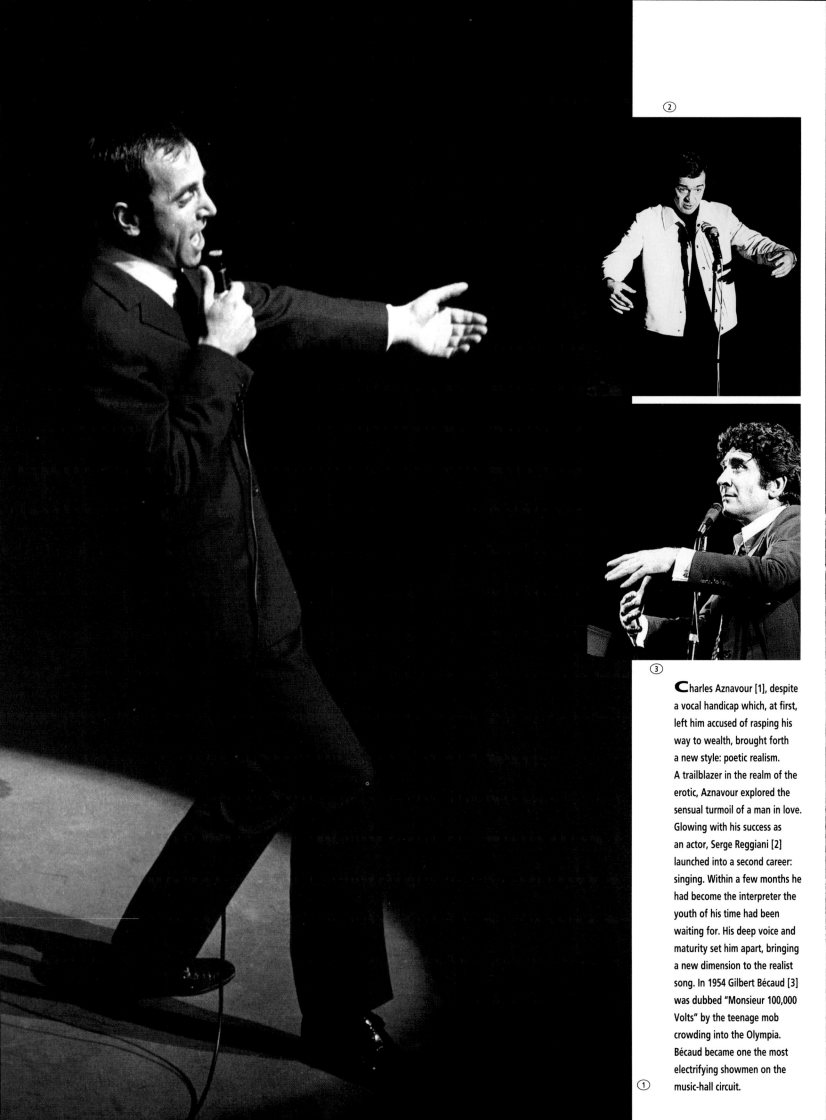

Charles Aznavour [1], despite a vocal handicap which, at first, left him accused of rasping his way to wealth, brought forth a new style: poetic realism. A trailblazer in the realm of the erotic, Aznavour explored the sensual turmoil of a man in love. Glowing with his success as an actor, Serge Reggiani [2] launched into a second career: singing. Within a few months he had become the interpreter the youth of his time had been waiting for. His deep voice and maturity set him apart, bringing a new dimension to the realist song. In 1954 Gilbert Bécaud [3] was dubbed "Monsieur 100,000 Volts" by the teenage mob crowding into the Olympia. Bécaud became one the most electrifying showmen on the music-hall circuit.

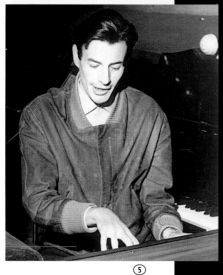

⑤

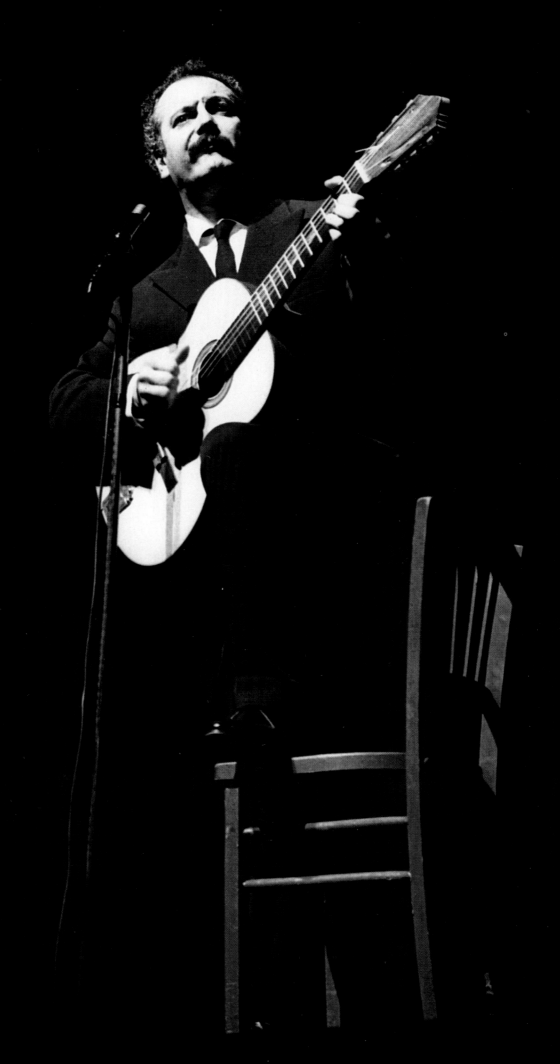

The Belleville street urchin Marcel Mouloudji [4] made his debut at the age of twelve in a Carné film, initiating a career that branched out into theatre, writing, painting, and song. He interpreted Queneau, Dimey, and Prévert and had major hits with *Comme un p'tit coquelicot* (R. Asso/C. Valéry) and *Un jour tu verras* (G. Van Parys). By contrast, Jean Ferrat [5], with his veloured voice, appeared more comfortable in a repertoire of amorous ballads. To everyone's surprise, he became the first "crooner" to place his charm in the service of ideas and political engagement. Georges Brassens [6], a triple-threat writer/composer/performer, revolutionized the French popular song by using swear words as if this were no more than plucking a daisy. ⑥

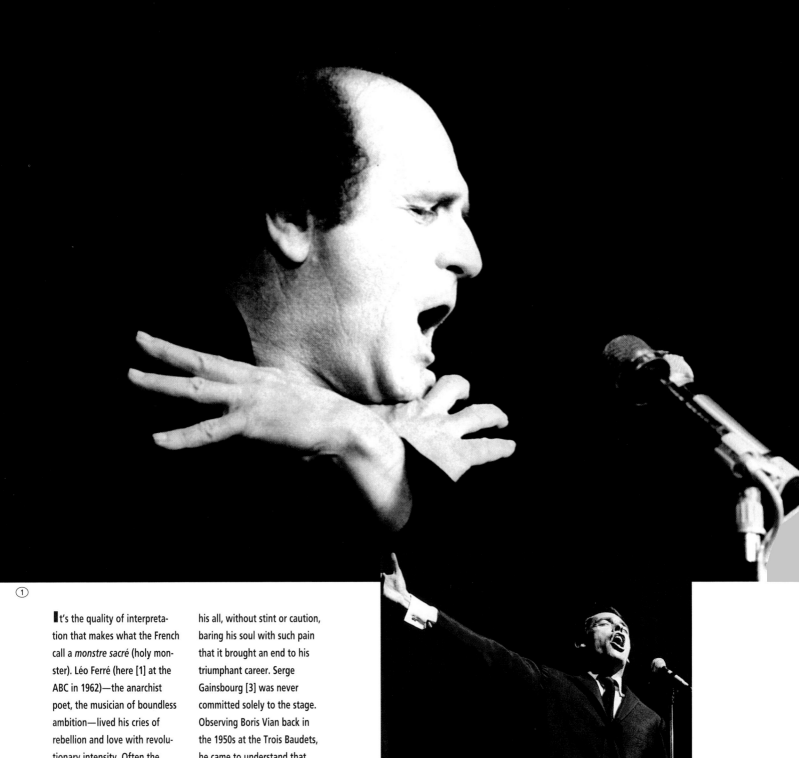

(1)

It's the quality of interpretation that makes what the French call a *monstre sacré* (holy monster). Léo Ferré (here [1] at the ABC in 1962)—the anarchist poet, the musician of boundless ambition—lived his cries of rebellion and love with revolutionary intensity. Often the effect was reinforced by attitude, because the more the singer longed to be useful, the more he had to be effective. Jacques Brel [2], during his farewell at Olympia in 1966, lived his recital as if it were a race against life. A creature of the theatre, he dared to give

his all, without stint or caution, baring his soul with such pain that it brought an end to his triumphant career. Serge Gainsbourg [3] was never committed solely to the stage. Observing Boris Vian back in the 1950s at the Trois Baudets, he came to understand that a singer didn't need to give live performances in order to have a career. Facing an audience is painful for anyone not in love with himself. After several obligatory attempts, Gainsbourg abandoned the stage, and did not return to it until the 1980s.

(2)

(3)

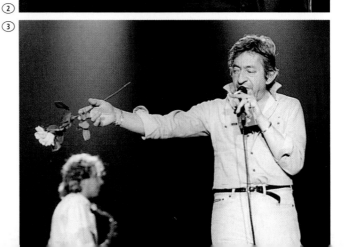

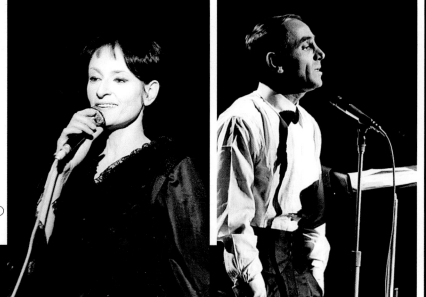

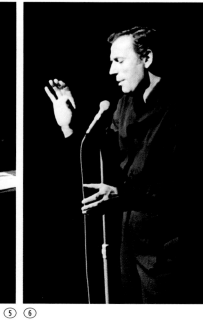

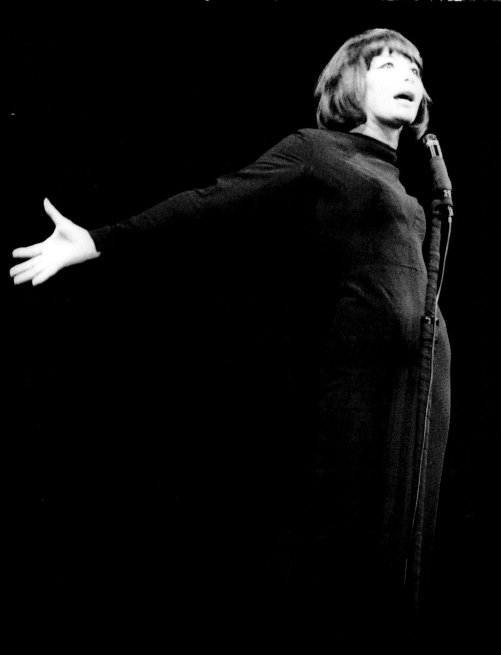

Juliette Gréco [7] and Barbara [4], the two dark ladies of French song, became over time the most adulated of divas. Their performances, gestural as well as vocal, their outrageousness and excess—all served to endow feeling with great power, a power shot through with the nuanced vibrations of human nature: humor, rage, sensuality, irony, tenderness. Charles Aznavour [5] and Yves Montand [6] discovered their way in song through an unremitting search for perfection. By the same token, precise gestures, considered effects, and controled voices left them open to criticism for the want of feeling. Still, theirs was a exacting craftsmanship which rewarded them both with international success.

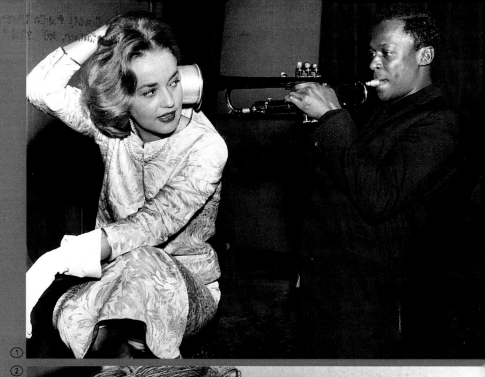

"Like our badabada voices," talent sometimes meets talent, on screen or on stage, sometimes in life itself. In *Ascenseur pour l'échafaud* (1957), Louis Malle arranged an encounter between Jeanne Moreau and Miles Davis, at least long enough for a photo [1]. Gérard Depardieu and Barbara indulged their fascination with one another in the film *Lily Passions*, a musical, operatic and baroque [3]. To please him, she turns herself into an actress, and to seduce her, he agrees to sing. Yet, despite their strenuous efforts, the meeting of these two *monstres sacrés* left audiences unconvinced.

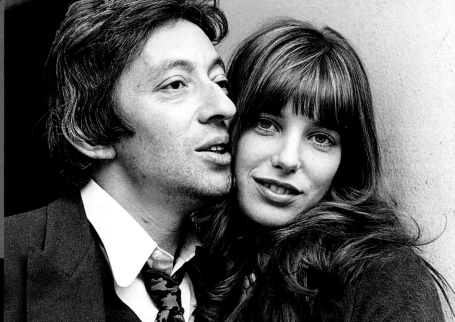

Slogan, the film of Pierre Grimblat, brings together an unknown young Englishwoman and one of the most famous *provocateurs* in all of popular song. Born in 1968, the Serge Gainsbourg/Jane Birkin coupling became a symbol of moral emancipation [2], giving rise to a song that scandalized as it traveled around the world: *Je t'aime moi non plus.*

Georges Moustaki served Édith Piaf to happy effect (*Milord*), but it was Barbara who, in the duet *La longue dame brune*, really brought him to public attention [5]. She also introduced him to Serge Reggiani, for whom he wrote several of his early successes. In 1951, however, Reggiani had yet to begin his singing career when he took up with Simone Signoret in *Casque d'or* [4].

(4)

(5)

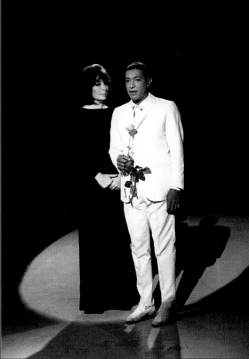

(6)

Juliette Gréco was the incarnation of a woman in love with freedom: *Je suis comme je suis je suis faite comme ça.* . . . A chance encounter on a television set may find her involved with a cast of unknowns (here [6] on the arm of Henri Salvador). However, she agrees to share billing only with an artist of exceptional standing. In 1966, at the TNP (Théâtre National Populaire), La Gréco undertook a joint recital with Georges Brassens and proved herself to be a great lady of song [7].

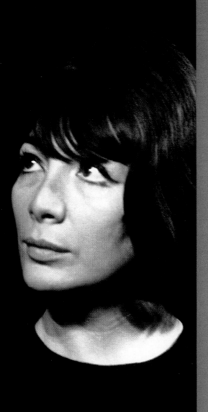

(7)

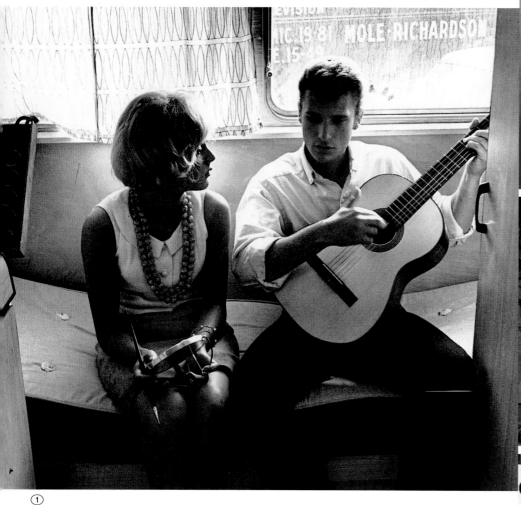

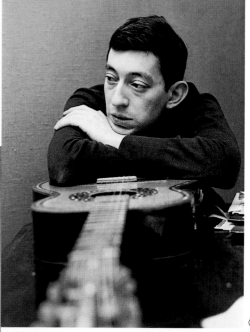

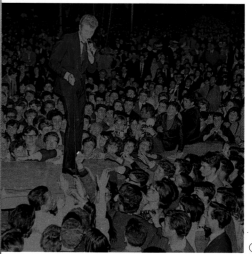

The yé-yé or "pop" wave rolled over France in the 1960s, sweeping away all the old stars—*les vedettes à papa*. The world of new idols represented a kind of Olympia in which children and adolescents alike found their identity. The royal couple in this magic kingdom were Johnny Hallyday and Sylvie Vartan [1]. In 1963 Noël Howard paired them on the screen in *D'où viens-tu Johnny?* In June of that year the new stars, among them Johnny [3], staged one of the events of the decade by giving a concert in the Place de la Nation. In April 1965 Johnny and Sylvie thrilled fans by becoming man and wife, or King and Queen.

Serge Gainsbourg [2] exploited his talent for irony to resist the oncoming tide. Writer for the sure-fire talents of the Left Bank (Michèle Arnaud, Catherine Sauvage, Juliette Gréco), he took aim at the darlings of the moment, giving variety some of its best numbers. In 1966 Jacques Dutronc [4] burst upon with scene with *Et moi, et moi, et moi*, to lyrics by Jacques Lanzmann, whose caustic refrain announced the end of the yé-yé sunami. Meanwhile, Dutronc, the critical and disconcerting dandy, married the intellectual of the new wave, Françoise Hardy [5], whose artistic director he had been for some years.

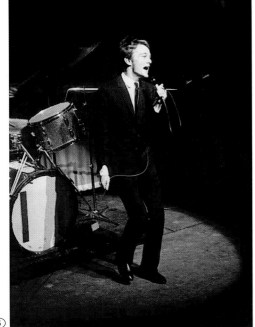

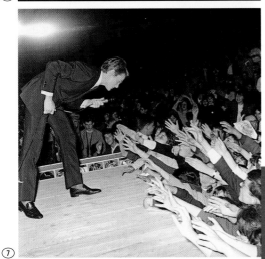

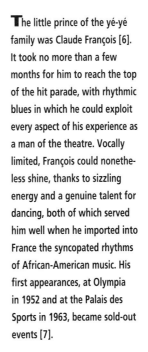

The little prince of the yé-yé family was Claude François [6]. It took no more than a few months for him to reach the top of the hit parade, with rhythmic blues in which he could exploit every aspect of his experience as a man of the theatre. Vocally limited, François could nonetheless shine, thanks to sizzling energy and a genuine talent for dancing, both of which served him well when he imported into France the syncopated rhythms of African-American music. His first appearances, at Olympia in 1952 and at the Palais des Sports in 1963, became sold-out events [7].

The early 1960s were marked by a tendency to adapt hits from the Anglo-Saxon world, relegating French composers to the background. In 1966 Michel Polnareff [10] stirred the embers of French song with *La Poupée qui fait non* (lyrics by F. Gérald). For his first appearances on television (as here in a telecast of 1966), Polnareff was so bold as to have himself accompanied by a unified combination of rock and classical musicians. One way to reconcile generations caught in a conflict of historic proportions. Then came 1968, when the confrontation took to the streets. Radio sta-

tions, captured by the rebels, broadcast nothing but music. Julien Clerc [8], a young man with a strange voice, as vibrant as an instrument, made a faultless debut with a piece by his favorite author, Étienne Roda-Gil. Following the earthquake came a kind of normalization initiated by the conservative middle class. The French popular song sank back into the variety mode. There were, however, a few exceptions, among them Alain Souchon [9], who, in 1973, invented a new kind of writing, borne on melodic wings crafted by his partner, Laurent Voulzy.

27

▲

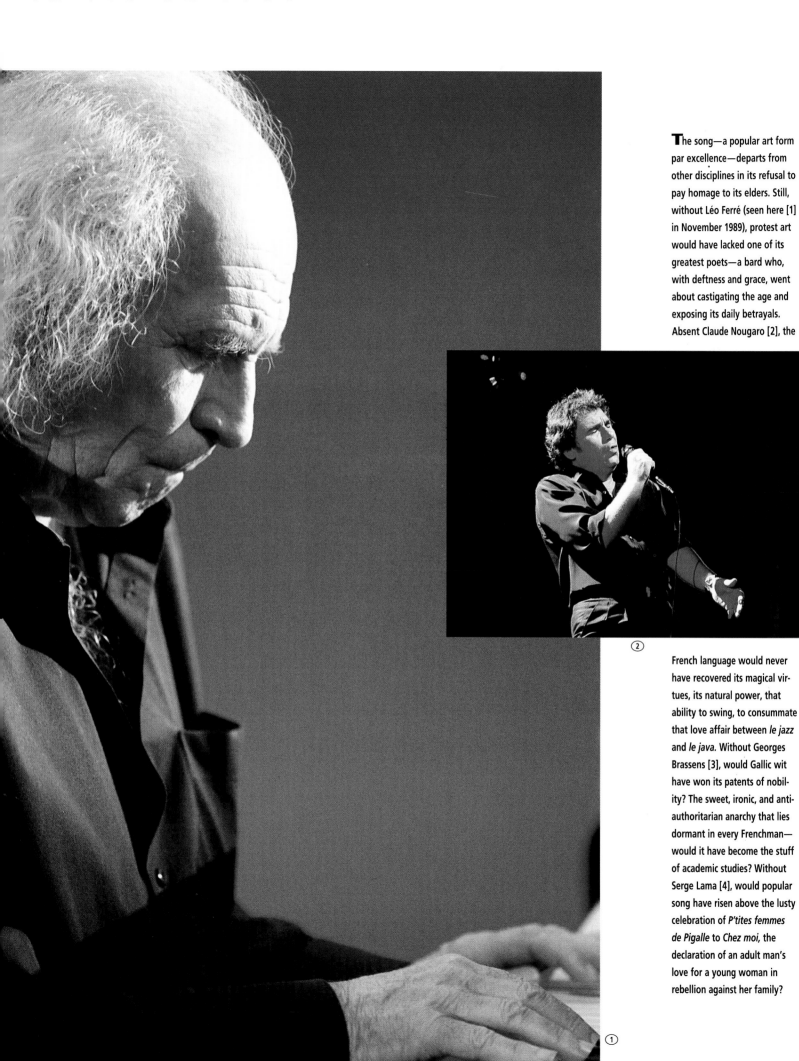

The song—a popular art form par excellence—departs from other disciplines in its refusal to pay homage to its elders. Still, without Léo Ferré (seen here [1] in November 1989), protest art would have lacked one of its greatest poets—a bard who, with deftness and grace, went about castigating the age and exposing its daily betrayals. Absent Claude Nougaro [2], the French language would never have recovered its magical virtues, its natural power, that ability to swing, to consummate that love affair between *le jazz* and *le java*. Without Georges Brassens [3], would Gallic wit have won its patents of nobility? The sweet, ironic, and anti-authoritarian anarchy that lies dormant in every Frenchman—would it have become the stuff of academic studies? Without Serge Lama [4], would popular song have risen above the lusty celebration of *P'tites femmes de Pigalle* to *Chez moi*, the declaration of an adult man's love for a young woman in rebellion against her family?

2

1

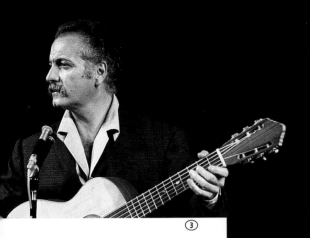

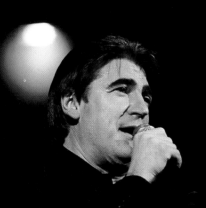

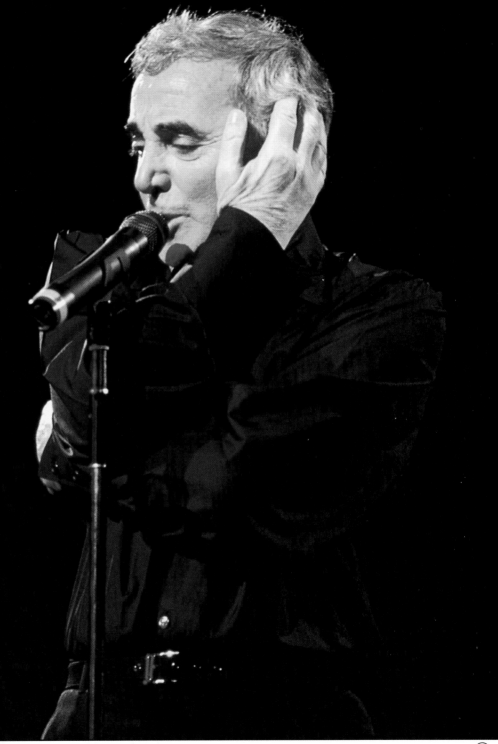

Without Charles Aznavour [5], would variety have dared to venture between the rumpled sheets of a pair of lovers *(Après l'amour)*? Would it have offered women mired in everyday life a well-polished and truthful mirror *(Tu t'laisses aller)*? Would it have consented to celebrate the solitude of a pathetic homo-sexual and a troubling humanity *(Comme ils disent)*?

The goddess has always haunted the music-hall stage. Somewhere between a vestal and a dominatrix, Juliette Gréco appears inaccessible, the embodiment of humanity's many myths, fantasies, and pains, its desires and dramas. Oracle of Saint-Germain-des-Prés, symbol of the Liberation at the end of World War II, La Gréco has become the emblematic figure of French song all over the globe. Ambassadress of poetry and of a feminity in which arrogance rhymes with glamour, she soldiers on, disdainful of fashion, trends, and other tics of the times, strengthened by a fragility acquired in the course of numerous affairs. From Jacques Prévert, a favorite poet, Gréco has appropriated a reflection and made it her own: *"La nouveauté, c'est vieux comme le monde* [Novelty, it's as old as the world]."

Authentic—sometimes to the point of caricature—Barbara spent a whole decade in Paris as the late-night chanteuse at the cabaret L'Écluse. Star long before she was famous, Barbara drew a fanatically loyal audience enraptured not only by a voice but also by phrasing of almost disconcerting originality. In 1964, when she abandoned other people's songs in favor of a repertoire all her own, Barbara finally got the attention of the public at large. She never betrays those who help make her special, always making herself a conduit for humanist, generous ideas, using music like a painter composing a picture, and letting her voice follow the fluctuations the years have imposed upon it.

Barbara and Serge Reggiani in 1965 [1]. Léo Ferré with Ivry Gitlis at the Théâtre Déjazet [2]. Édith Piaf in 1941 at Albert Préjean's with Marie Bizet and, at the piano, Marguerite Monnot, the composer best known for *Mon Légionnaire, L'Hymne à l'amour,* and *Milord* [3]. Jean Ferrat and Jacques Brel together on a television sound stage in 1969 [4]. Simone Signoret, Yves Montand, Jeanne Moreau, and Jean Marais [5]. Charles Trenet and his pianist [6].

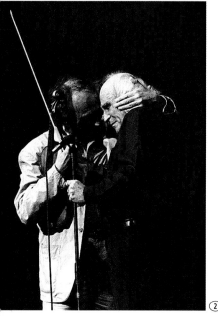

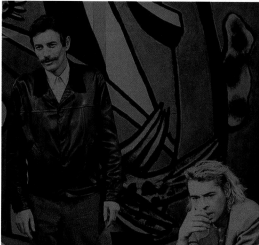

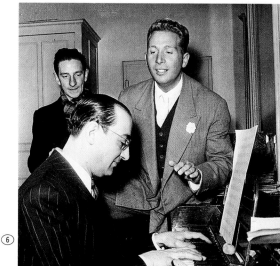

Amitié—friendship—is the feeling closest to love, and can sometimes take on the same form.

This was a fashionable subject during the 1930s, thanks to *Avoir un bon copain,* a hit song interpreted by Henri Garat, a young leading man in the first sound films and movie musicals. I don't remember any music with this theme before the arrival of Gilbert Bécaud, whose *C'était mon copain* (1953) memorialized a friend killed during the war.

The *amitié* song which most caught the yé-yé generation was unquestionably *Salut les copains,* a small flight of fancy that scarcely seemed freighted with the sociological import it would soon bear. At the time I was program director for a new radio station: Europe No. 1. With my collaborator Lucien Morisse, we were looking for a theme and a program title with appeal for the young, fully aware that we were evolving into a consumer society on the American model. Lucien said to me: "Your song *Salut les copains* goes over pretty well, so let's use the title for our program." Daniel Filipacchi, who produced a jazz program with Franck Thénot, was brought in to conduct, which he did admirably, with the result that the song became emblematic of a new generation, mad about rock'n'roll, blue jeans, and Coca-Cola.

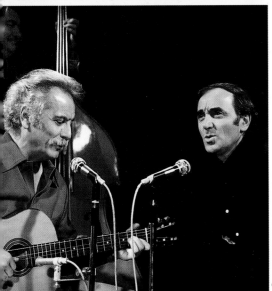

Here's an example of a song that transcended its role as entertainment to become an emblem, a rallying sign for the sixties generation, its youth more gregarious and certainly more involved with music and dance than earlier waves.

The word *copain*—pal or chum—proved lucky, particularly for Daniel Filipacchi who used it as a title for his first foray into publishing. *Copain* was then dethroned by *pote,* a word that, to my knowledge, has yet to inspire a song.

A list of works on the subject would have to include Francis Lemarque's *Mon copain d'Pékin,* which arrived a bit earlier than *Salut les copains; Tous mes copains* by Sylvie Vartan, the new pop star; and *Le Sifflet des copains* as sung by Sheila. Even the great Brassens made it one of his battle cries in *Les Copains d'abord. L'Équipe à Jojo* by Joe Dassin and Claude Lemesle took up the cause of fraternal bonding, just as Bécaud did in *L'Absent,* albeit on a more somber note. The authors of this piece also wrote *Un peu d'amour et d'amitié,* which became a smash hit in England. *San Francisco* by Maxime Le Forestier recalls a beautiful moment of friendship in a "blue house" overlooking the Pacific. The title of Aznavour's *Camarade* says it all.

The list could go on, but it should already be clear that friendship can't provide quite the inspiration love does.

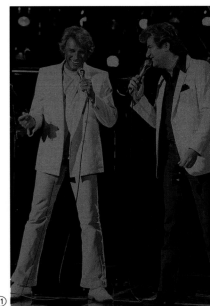

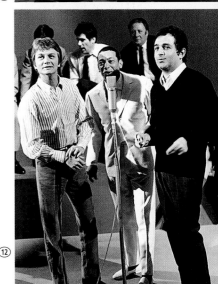

Sous le

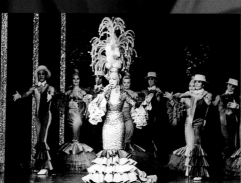

cíel

de París

The popular song has long been one of France's most important "exports," a product, like perfume or haute couture, which allowed Paris to make its presence felt throughout the world. From 1919 to 1923, Mistinguett enjoyed what was surely the most brilliant period of her long career [1]. She starred in such revues as *Paris qui danse*, *Paris qui jazz*, and *Paris en l'air* before leaving for the United States, where she became famous for her rendition of *My Man*. Mistinguett spent a year in America and then returned to the Casino de Paris. Now she introduced her famous *Bonjour Paris!*, to which the audience responded: *Bonjour la Miss!* In October 1925 Josephine Baker erupted on the stage of the Théâtre des Champs-Élysées, arriving there with the *Revue Nègre* company [2]. She caused a sensation, triggering reactions both divided and extreme. For some the performance was scandalous: "a strange person, who walks bent-kneed, dressed in ragged underpants, and who could be a boxing kangaroo . . . or a bicycle racer." Others saw her as the very model for a new kind of elegance. La Baker conquered Paris, settled there, and became a national treasure, equal to those ambassadors of French song: Maurice Chevalier and, later, Charles Trenet and Édith Piaf [3].

N

ow, for a change of pace, let's move on to Paris. Even if the capital has ceased to be the *paname* so rhapsodized by Mistinguett and Chevalier, Paris is still Paris. Songs about the city, it seems to me, can be divided into three periods, the first two extremely rich and the third a bit anemic.

First came the Belle Époque, followed by the heady years between the two World Wars, which together take us from around 1900 to the death of De Gaulle—two-thirds of the twentieth century. It was a time of joyous, over-the-top celebration of *la ville lumière*—the city of lights.

This Golden Age started with the folkloric fare of Aristide Bruant, whose Paris was Montmartre, a somewhat guttersnipe and beggarly place. There were songs about the jails, the old quarters, the narrow, winding streets of the *butte*, among them *La rue Saint Vincent*. Also popular were ballads about the glorious black cat of Rodolphe Salis (the founder of the famous Chat Noir cabaret), all of which the mad poet Francis Cover tried to revive in the 1950s. Today Bruant's songs form part of the patrimony of Paris, and *La rue Saint Vincent* could still bring tears, if only it were sung more often.

Next came the two troubadours of *paname* (the argot-speaker's Paris)—Mistinguett and Chevalier, the crowned heads of French music hall. Their reign lasted from 1910 to 1960, half a century chock full of masterpieces: *Paris reine du monde*, *Paris c'est une blonde*, *Ça c'est Paris*, *Paris sera toujours Paris*, *La plus belle ville du monde*, *Les*

①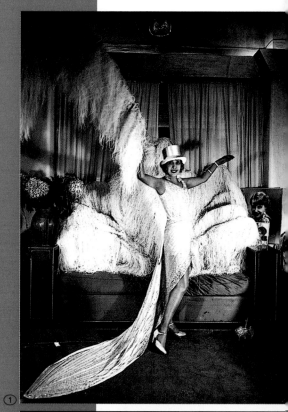

②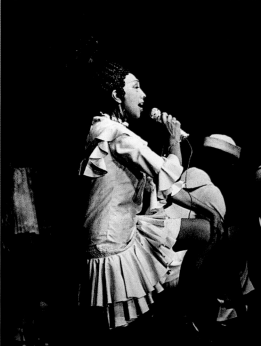

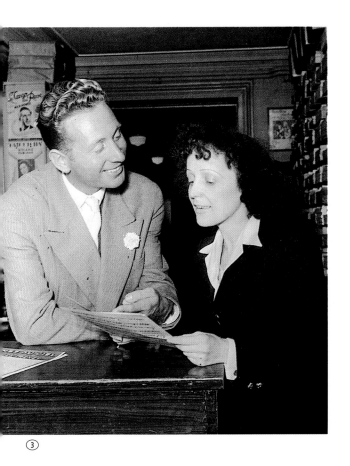

③

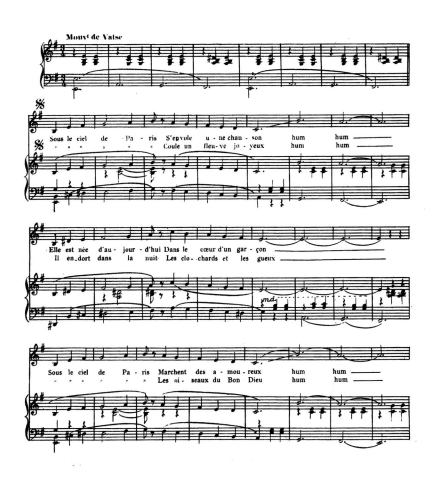

Lyrics : J. Dréjac ▪ **Music** : H. Giraud, 1959

Sous le ciel de Paris
S'envole une chanson
Hum, hum
Elle est née d'aujourd'hui
Dans le cœur d'un garçon
Sous le ciel de Paris
Marchent des amoureux
Hum, hum
Leur bonheur se construit
Sur un air fait pour eux
Sous le pont de Bercy
Un philosophe assis
Deux musiciens quelques badauds
Puis les gens par milliers
Sous le ciel de Paris
Jusqu'au soir vont chanter
Hum, hum
L'hymne d'un peuple épris
De sa vieille cité

Près de Notre-Dame
Parfois couvre un drame
Oui mais à Paname
Tout peut s'arranger
Quelques rayons
Du ciel d'été
L'accordéon d'un marinier
L'espoir fleurit
Au ciel de Paris
Sous le ciel de Paris
Coule un fleuve joyeux
Hum, hum
Il endort dans la nuit
Les clochards et les gueux
Sous le ciel de Paris
Les oiseaux du Bon Dieu
Hum, hum
Viennent du monde entier
Pour bavarder entre eux

Et le ciel de Paris
À son secret pour lui
Depuis vingt siècles il est épris
De notre île Saint Louis
Quand elle lui sourit
Il met son habit bleu
Hum, hum
Quand il pleut sur Paris
C'est qu'il est malheureux
Quand il est trop jaloux
De ses millions d'amants
Hum, hum
Il fait gronder sur nous
Son tonnerre éclatant
Mais le ciel de Paris
N'est pas longtemps cruel
Hum, hum
Pour se fair' pardonner
Il offre un arc-en-ciel.

④

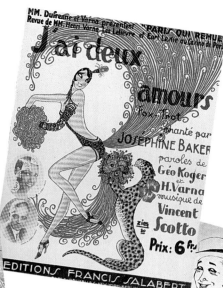

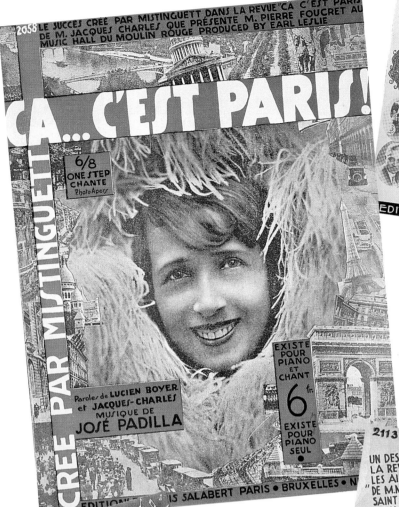

In 1926 Mistinguett—by then a "national treasure"—sang the immortal *Ça c'est Paris* in the revue of the same title. In 1930, for the debut of Josephine Baker at the Casino de Paris, Géo Koger and Vincent Scotto created what would become her signature number: *J'ai deux amours . . . mon pays et Paris.* Even more than records, the movies did much to disseminate the image of singers. Charles Trenet became an early star of minor films with titles taken from the featured songs. In 1938 *Boum* [2] and in 1941 *La Romance de Paris* brought him considerable fame. Throughout his life Georges Ulmer would sing *Pigalle*, the song that located him among the immortals. After the Liberation, *Pigalle* became a kind of international hymn to a Parisian *place* familiar to tourists around the world. Édith Piaf ventured into films whose only *raison d'être* was to showcase the voice and face of their star. One exception was her appearance in Sachy Guitry's *Si Versailles m'était conté* [1], in which she gave an unforgettably rousing interpretation of the revolutionaries' song of 1789: *Ah ça ira, ça ira!* In 1931, Maurice Chevalier, haloed in Hollywood glory, was often solicited to appear at charity galas, where he never failed to exude his famously cocky, Parisian charm [3].

gars de Ménilmontant from Maurice to the young crazy singing *La tour Eiffel part en balade comme une folle.*

Liberated in 1944, Paris recovered from four years of darkness and despair. The postwar period brought first *Fleur de Paris* by Henri Bourtayre and Maurice Vandair.

The Seine itself got into the act, inspiring Lucienne Delyle, *Les quais de la Seine, Les Amants de Paris,* and *Sous le ciel de Paris,* the last a marvelous piece still popular throughout the world as *Under Paris Skies.* Next came *À Paris,* Francis Lemarque's hymn to Paris, first performed with such verve by the author himself and then reprised by one of the century's greatest, Yves Montand. Here's a refrain that never stops tickling the brain—*"longtemps, longtemps, longtemps, après que le poète aura disparu."*

La Seine by Guy Lafargue enjoyed a good decade of success, and one day it could very well return to its source. *Les Grands boulevards, Rue de Lappe, À la gare Saint Lazare, Mademoiselle de Paris, La Complainte de la Butte, Moulin Rouge,* Gainsbourg's *Le Poinçonneur des Lilas,* and many others I can no longer remember.

It could be argued that every writer and/or composer has written his song, and perhaps his best song, on *la ville lumière.*

Then came the yé-yé or pop wave, which rolled over old Paris and swept it out of fashion, a *ville à papa* which suddenly appeared old hat in the eyes of a generation besotted with everything American.

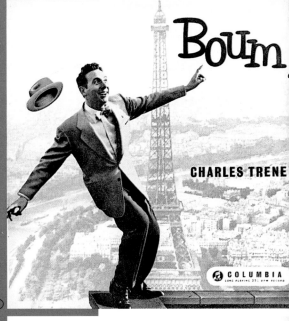

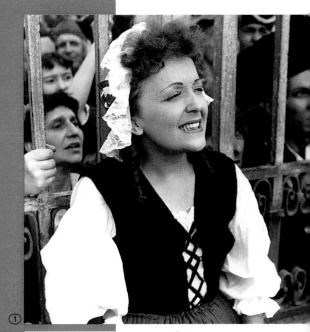

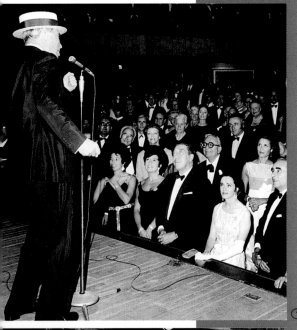

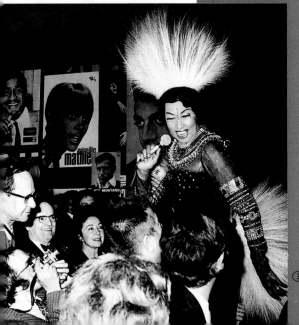

As for myself, I turned out three songs, one for Juliette Gréco and another for Alice Dona, neither of which caught fire. I also wrote *Les Champs-Élysées,* a number for Joe Dassin adapted from an English song, *Waterloo Road.*

Léo Ferré proved a magnificent exception with his *Paris Canaille,* as did Charles Aznavour with *Paris au mois de mai et au mois d'août,* and even the Americans with their *April in Paris.* For our transatlantic cousins, Paris, despite everything, remains the capital of elegance, champagne, and pretty women. I almost forgot *La Parisienne,* that irresistible fantasy created by my darling friends, Marie-Paule Belle and Françoise Mallet-Jorris.

As for other cities in song, there is Venice, already mentioned, as well as Capri, Ajaccio, Marseilles *(Tais-toi Marseille),* Claude Nougaro's *Toulouse,* and, for a joke, *Le clair de la lune à Maubeuge.* Also worth citing are Paimpol and its seacliff, Brel's Brussels, Trenet's Collioures, Sinatra's New York, Peyrac's Los Angeles, Rio and its samba, Vienna and its waltzes. For Joe Dassin there is the *café des trois colombes* at Nancy, and for Barbara, *Nantes.* That's about it.

Hands down, Paris is the queen of song. With Jean-Pierre Bourtayre, I've recently written a song about the new Paris—la Défense—but it has yet to be released. Meanwhile, I'll share a few lines with you: *"New Paris c'est pas Manhattan / Mais ça n'est plus non plus Paname / C'est la ville qui prend ses distances / à la Défense."*

The live stage remains the place where the artist comes most genuinely into his own. Nothing could be more narcissistic, one person flooded with light and determined to seduce several thousand anonymous individuals facing him or her in the dark. Maurice Chevalier [1] has always been the master of this situation. A child of the people, he made his debut at the age of twelve at Asnières in a *caf'conc* called Éden-Music. He had taken a stage name: Petit Jésus d'Asnières! Sixty-three years later, at the Théâtre des Champs-Élysées, Chevalier gave a farewell performance in which he told his life story punctuated with reprises of his hit numbers.

Mademoiselle de Paris—written in 1947 by Henri Contet, composed by Paul Durand, and performed by Jacqueline François [2]—was one of the first great successes of the postwar years. It expressed the feelings of joy and freedom that came with Liberation in August 1944. Thanks to *Mademoiselle de Paris,* Jacqueline François became the first to have a record with a million-copy sale. Henceforth there would be no stopping this singer.

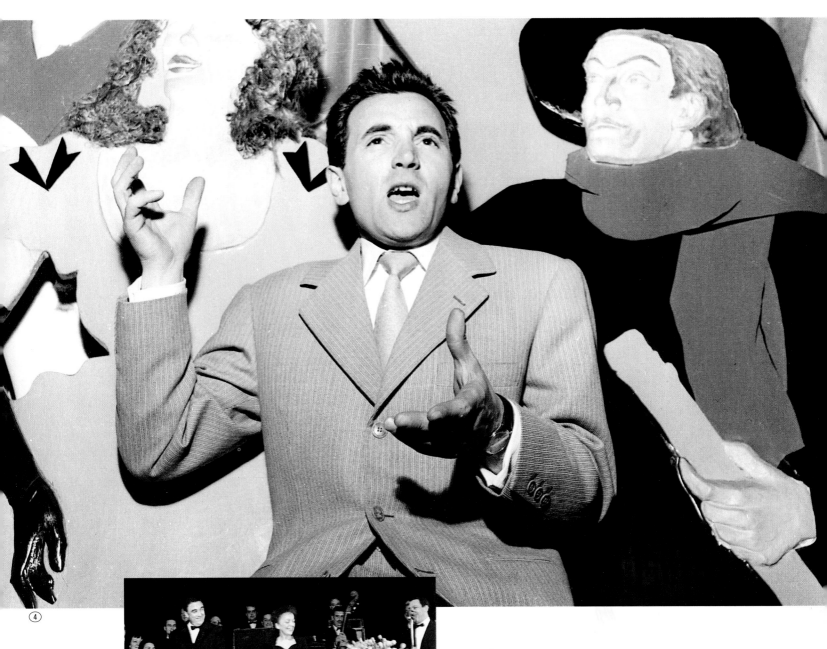

In 1975 Josephine Baker [3 and 6] celebrated her fiftieth birthday at Bobino, starring in a review directed by André Levasseur. It would be her last appearance, after which a dizzy spell forced her to cancel. She died several days later. Before the Moulin Rouge degenerated into a tourist trap dedicated to revues featuring girls with bare breasts, it had been a music hall that presented variety shows and later programs of popular song. Here, in 1951, Charles Aznavour [4]. Édith Piaf [5], moving from triumph to triumph, ended her life more or less on the stage, at the Olympia in 1962, totally spent at the age of forty-eight.

the Paris of Trenet

When a young Catalan named Charles Trenet arrived in 1937—a carnation on his lapel, a twinkle in his eye, velvet in his voice—he all but danced on the piano as he unfurled that incomparable style, those couplets of incongruous words set to music torridly flirting with jazz. The blasé, demanding Parisian audience could not get enough of him. Within a few years he had become almost a one-man revolution, a "flash in the pan" that lasted, as Cocteau put it. Despite a few troughs among the cresting waves of popularity—especially in the 1960s (above at the Locomotive in 1964 during the Goodwill Tour), a period when the yé-yés dominated the scene, totally unaware that it was the "singing fool" who had paved the way for them— Trenet remains the pre-eminent figure in the realm of modern song. He is also atypical, a musical personality in a class by himself, in his own little personal theatre. From gala (here in 1953, at right below) to recital, he symbolizes the French song, and, come what may, history will be written in terms of song before Trenet and song after Trenet.

la vie en rose

After four years of war and humiliation, the young people of France rediscovered themselves in Saint-Germain-des-Prés [1], eager for friendship, freedom, and projects. Many are those who came to breathe the intoxicating air of this Left Bank quarter, epicenter of the "all clear" and the revived spirit sweeping through Paris and the world. Within a few months, unknowns had become famous, thanks to *caves* or cellar cabarets filled with artists and intellectuals. Juliette Gréco [6] made her debut at the heart of this magnet of creative activity. Very quickly she emerged as the oracle of the *germanopratins* (those denizens of Saint-Germain-des-Prés), which she remains to this day. Seen here with Françoise Sagan, the cult novelist who wrote lyrics for several of her songs, and with Michel Magne at the piano [4], Gréco stands forth in all her beauty, the silhouette and the glamour virtually emblematic of Saint-Germain-des-Prés. Le Tabou, the first *cave* to become a cabaret, provided the stage from which Gréco began a long run during which she championed a kind of poetry and song unique to France [8]. Cora Vaucaire (here [2] in 1957) was something else, *la dame blanche*, the "white lady," of Saint-Germain. She too sang the poets, and successfully, for years, in every cabaret on the Left Bank. It was Vaucaire who premiered *Les Feuilles mortes* by Prévert and Kosma. Catherine Sauvage (here [3] in 1965) gave Saint-Germain-des-Prés the chance to discover the songs of a young writer/composer from Monaco, Léo Ferré (here [5] in 1961). The Left Bank had difficulty coming around to this gifted artist/provocateur, who had to wait several years before he found himself accepted as an interpreter of his own material. Mouloudji, a child-actor already famous by the time of his 1952 appearance at Tabou [7], grew up in the quarter, where he even became a novelist (*Enrico*, 1946), while also remaining a singer.

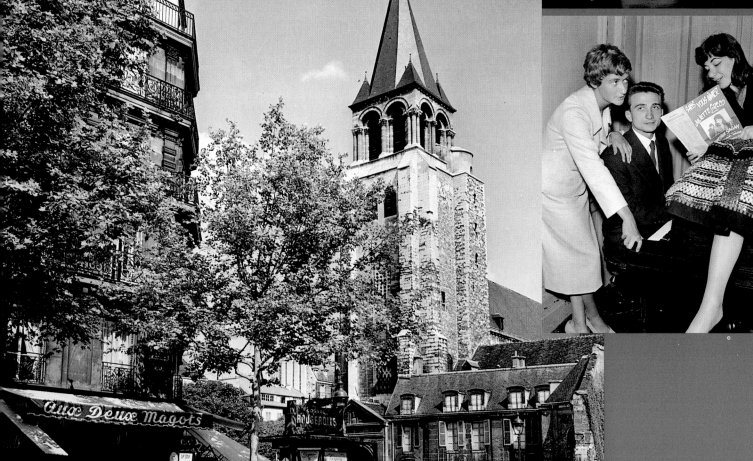

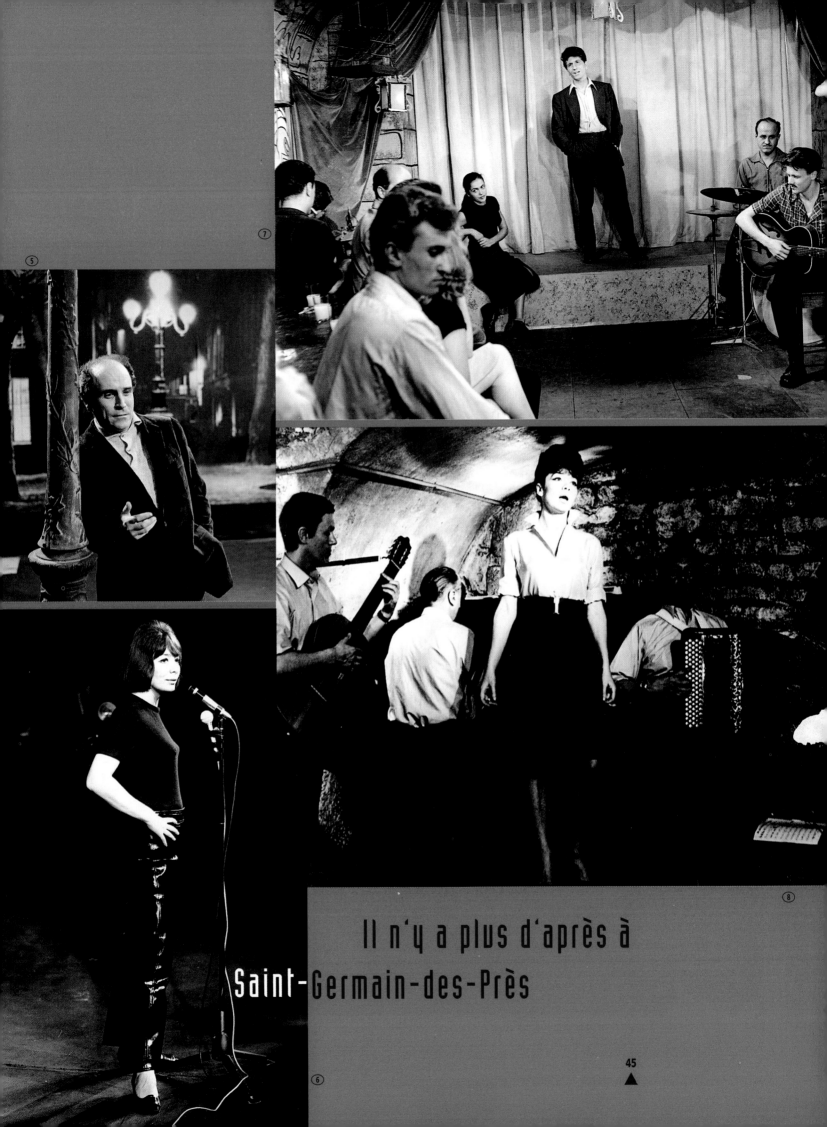

Il n'y a plus d'après à
Saint-Germain-des-Près

It's joy that makes Paris sparkle. The joy of sharing moments with unknown admirers in a brasserie, just as Georges Brassens was doing here [1]. The joy of living a hard-won success like that of Jean Ferrat [2], who, in several 45 rpms, made hits of ambitious, poetic, and sometimes politically engaged songs. Thanks to his plummy voice and superb melodies, he succeeded in popularizing the verses of Louis Aragon and exploring serious themes, as in *Nuit et brouillard* or *Potemkine*. The joy of Georges Brassens [3] greeted in his Bobino dressing room in October 1972 by Jane Birkin and Serge Gainsbourg. Here was the joy of fellow artists, each of whom, in his or her time and fashion, caused some kind of scandal. The joy of the writer/composer and his interpreter [4] who bring before the public songs that challenge current fads. In 1969 Georges Moustaki wrote and composed *Sarah, Ma liberté . . .* , and several of the major hits in the repertoire of Serge Reggiani, an established actor but a newcomer in the music hall.

②

③

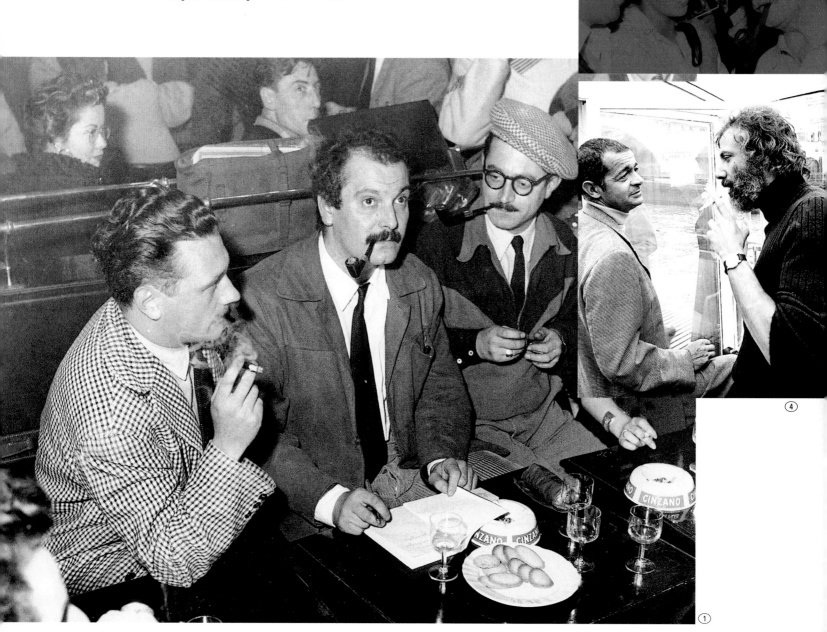

④

①

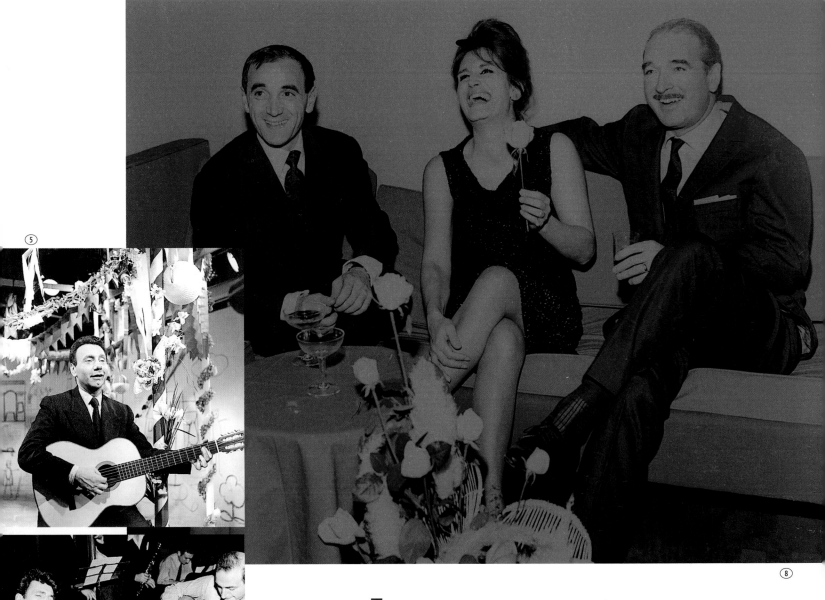

The joy of the artist who, in a single number, creates a hymn of love to the City of Light. Francis Lemarque [5], the writer and composer of the immortal *À Paris,* the title of every Yves Montand show. The joy of singing accompanied by one of the best: Yves Montand with guitarist Henri Crolla [6], the composer of, among other pieces, *Sanguine* with lyrics by Jacques Prévert.

The joy of collaboration between two stars on the rise.

In 1959, backstage at the Olympia, Charles Aznavour, the author, and Gilbert Bécaud, the composer, had every reason to smile, given the bright future they had before them [7].

The joy of a producer with a hit on his hands. Eddie Barclay, jazz musician and importer of LPs, got involved with songs for business reasons but also out of love for the art. Here [8] he savors the success of two artists under contract to him: Dalida and Aznavour.

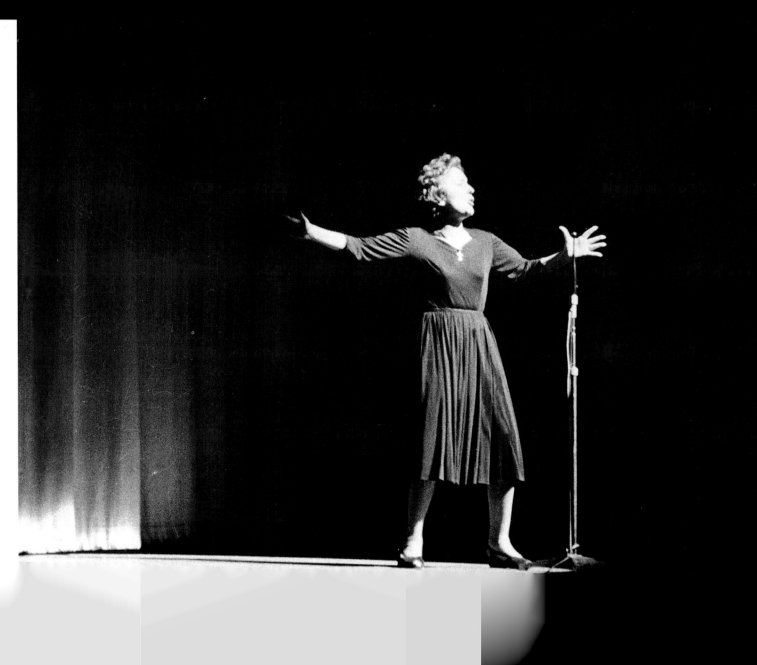

In 1888 Joseph Oller, creator of the Pari-Mutuel, installed in a vast courtyard once used as *fiacre* stables the famous Russian Mountains imported from Blackpool. They lasted four years, to the great delight of Parisians. Built entirely of wood, the Russian Mountains would be demolished in 1892 by order of the Préfecture de Police, who worried about fire. Oller, aware of the site's value, decided to build a music hall with two thousand seats: the Olympia. After many vicissitudes, which resulted in a transformation of the music hall into a cinema, Bruno Coquatrix restored the Olympia in 1952 to its original purpose. Wisely enough, he continued for a year to show films, but filling the intermissions with a series of programs featuring singers.

①

In April 1953 Bruno Coquatrix introduced *Baratin*, an operetta by Henri Betti and André Hornez. Encouraged by this success, he decided to experiment with variety shows in the classic manner, assembling mixed programs composed of a star performer preceded by international acts and fledgling singers. Thus, on 5 February 1954 the Olympia-Bruno Coquatrix Music Hall presented Lucienne Delyle, Aimé Barelli and his orchestra, and, as a curtain-raiser, a young unknown composer named Gilbert Bécaud [1]. Before long, a gig on the Olympia stage became obligatory for any singer desiring to build or solidify a reputation in France. Édith Piaf [2], Jacques Brel [3], and Yves Montand [4] all performed there. The only artist Bruno Coquatrix failed to capture, because of the high fee, was Elvis Presley.

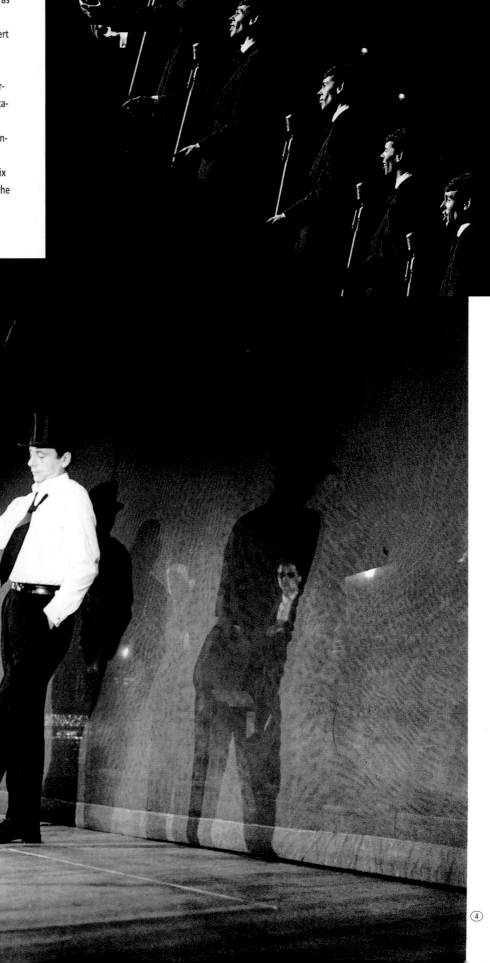

③

④

Paris, the hospitable city, has long been a goal of artists from around the world. Recognition by the Parisian public is tantamount to a sacred investiture. During the 1950s it was in Paris that the new wave in variety drew its roots. Claude François [1], arriving from Egypt, began as a drummer for various bands. In 1963 he won the public's favor with *Belle, belle, belle*, thereby launching a career that would make him the arch-rival of Johnny Hallyday. The Belgian Hallyday, meanwhile, rode high on hard rock, beginning in 1959. Another child of the people, he grew up in the wings of circuses

and music halls. At fifteen, he discovered the jukebox at the Golf Drouot [2] and decided to emulate his American idols. Within months the Hallyday phenomenon had become a tidal wave, sweeping aside every convention and opening the doors to a new generation of singers. By 1965 the yé-yés had been left behind, while variety assumed a nostalgic air, touched with romanticism and poetry.

With Salvatore Adamo [3] the poetry could sometimes be tender. A Belgian of Sicilian origin, Adamo arrived in Paris as a singer with a repertoire of blues sure to touch the heart of

shopgirls, despite his strange, rather hoarse voice. Michel Joansz [4] had some initial difficulty making his mark in the world of popular music. With a vibrato betraying his Hungarian background and devotion to the blues, Joansz sang of pain and hope like no one before him.

Jacques Dutronc [5] chose the year 1968 in which to expand his repertoire to include a love song to Paris. *Il est cinq heures Paris s'éveille* describes the life that takes possession of the great city as night recedes. With this he revived a theme well known during the last century.

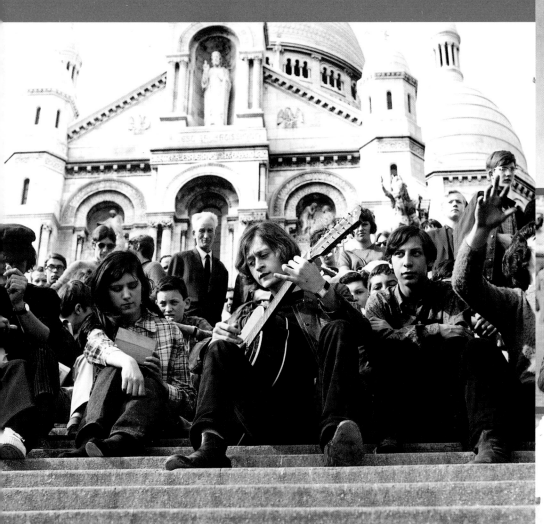

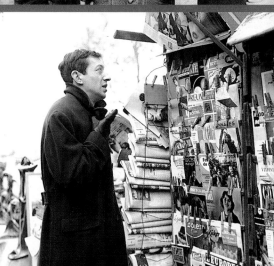

It was on the steps of Sacré-Coeur, among the beatniks of the 1960s, that Russian-born Michel Polnareff [6] earned his first money as an artist making the rounds. Among the listeners whose attention he caught was a publisher willing to record *La Poupée qui fait non*. It was an instant hit. Melodies, voice, arrangements—all seduced the public at large despite the provocative look. Jeanne Moreau [7], whose mother was English, sang *Le Tourbillon* by Cyrus Bassiac (aka Rezvani) in 1963 in François Truffaut's unforgettable film *Jules et Jim*, revealing genuine talent as a singer. The film was beautiful and also a

scandal, creating for all the world the supreme image of the beautiful Parisien, elegant, brazen, sensual, and free. Joe Dassin [8], an American, settled in France and, by chance, made a record, the first in a long series. Popular, laid back, seductive, he went on making hits, among them a number about the world's most beautiful avenue, *Aux Champs-Élysées,* which became one of the best known French songs in the world. Serge Gainsbourg [9], son of a Russian pianist, enrolled in the École des Beaux-Arts, hoping to become a painter. To pay his way, he became a bar pianist and soon

abandoned painting in order to accompany Michèle Arnaud and Milord l'Arsouille. Watching Boris Vian sing at the Trois Baudets, he realized that a singer didn't necessarily have to be the airhead portrayed by the media. He became one of the treasures of the Left Bank. Although harboring a certain contempt for variety, which he considered a minor art, Gainsbourg had no difficulty taking a leaf out of the yé-yé book. Shamelessly, he cocked a sharp eye at this fad and won the Grand Prix de l'Eurovision in 1965 with *Poupée de cire poupée de son,* written for France Gall [10].

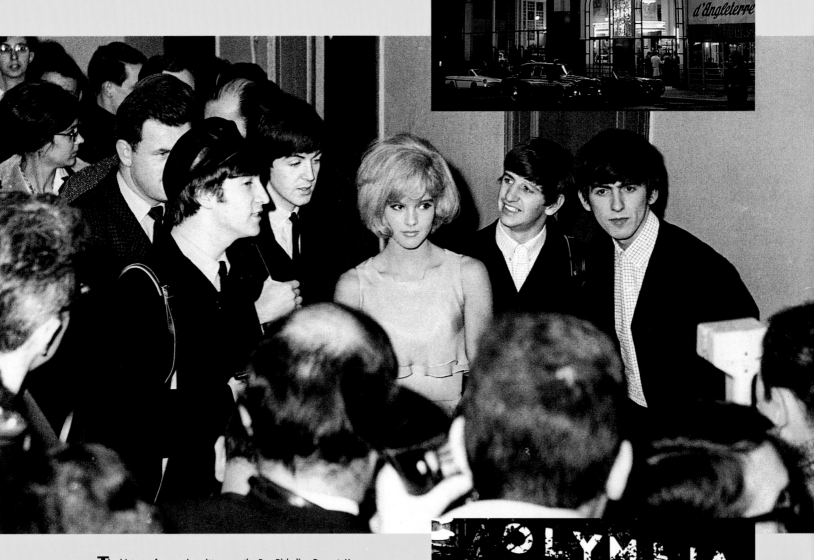

The history of an era is written in music halls. The artists who fill the theatres sanctify the desires, fantasies, and hopes of the moment. In 1964 an historic show at the Olympia, a bill which included Pierre Vassiliu, Sylvie Vartan, Trini Lopez, and the Beatles, the last still little known in Paris. The following year the Beatles returned radiant with universal glory, teaching Sylvie Vartan the value of being photographed in the company of the Fab Five [above]. At the beginning of the sixties the world of song found itself in turmoil. The cradle of the new stars was a former miniature golf course located on the upper floor of a building in the Rue Richelieu-Drouot. Here, for the first time, was a club dedicated to the young, complete with Coca-Cola and a juke box pouring out rock and roll, the latter banned from national radio and television. The Golf Drouot was a tremendous success, and within a few months Henri Leproux would provide the springboard for the top billings of the next decade. Now came the obsession with youth and the invention of "show business." As a result, singers whose talent remained more or less latent found themselves catapulted from the Golf Drouot right onto the Olympia stage, with names writ large in bright red lights.

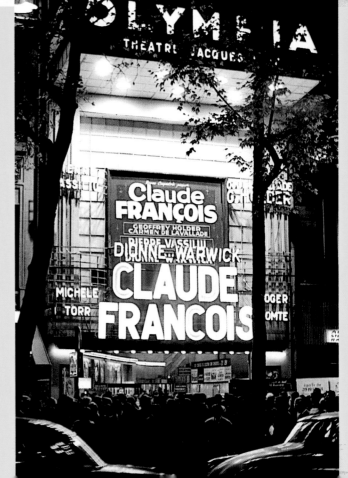

The new wave lifted all boats, save, of course, the established stars—*les artistes à papa*—who appeared regularly at the Casino de Paris. In 1893 the Élysée-Montmartre, one of oldest of Paris's dance halls, saw its popularity fade once the Moulin Rouge had opened. The owner decided to follow the trend and transform his establishment into a *café-concert*. The opening was announced as follows: *"Grand jardin de Montmartre, tous les soirs, Trianon-Concert:* spectacle varié." The premiere show was entitled *Trianon-Paris*, and it included a tiny role for a sixteen-year-old girl who had just taken her first steps on the stage at the Casino de Paris: Mistinguett.

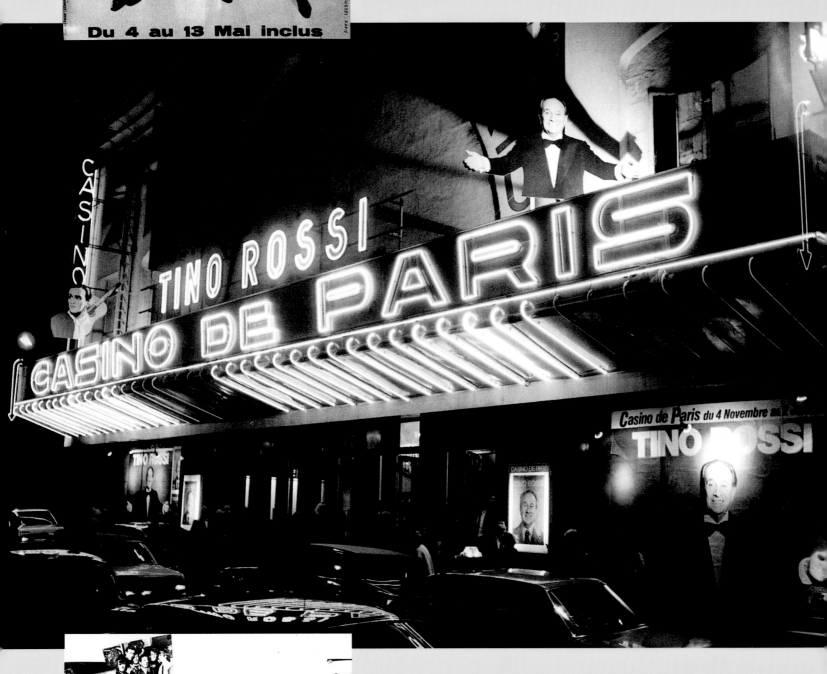

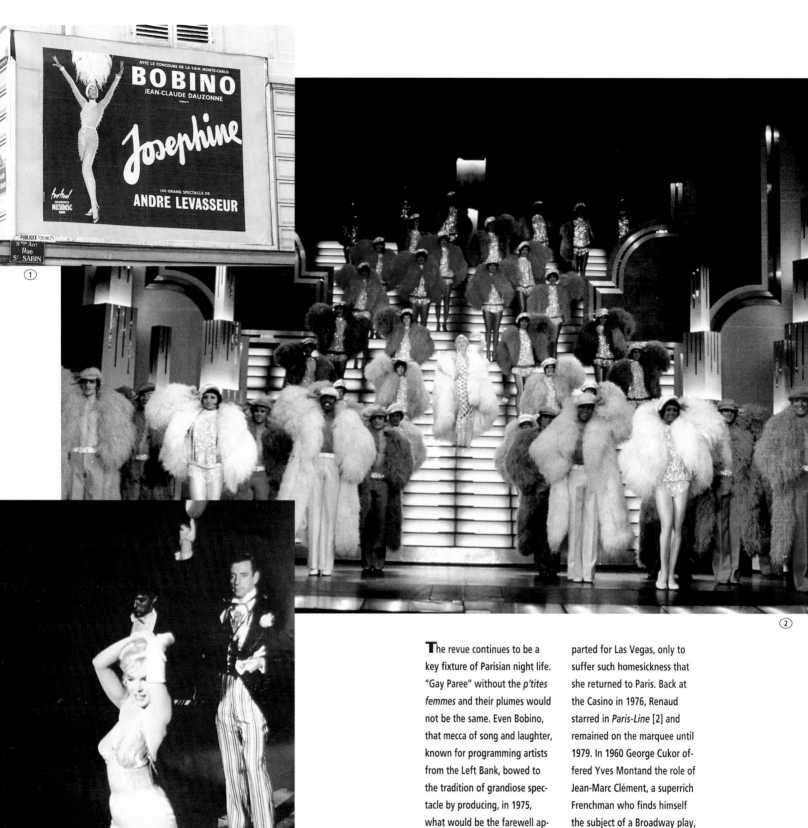

The revue continues to be a key fixture of Parisian night life. "Gay Paree" without the *p'tites femmes* and their plumes would not be the same. Even Bobino, that mecca of song and laughter, known for programming artists from the Left Bank, bowed to the tradition of grandiose spectacle by producing, in 1975, what would be the farewell appearance of Josephine Baker [1]. In 1958 Line Renaud, an important star of the postwar era, accepted an invitation from Henri Varna and took up residence on the stage of the Casino de Paris. Having thus scored a hit, she departed for Las Vegas, only to suffer such homesickness that she returned to Paris. Back at the Casino in 1976, Renaud starred in *Paris-Line* [2] and remained on the marquee until 1979. In 1960 George Cukor offered Yves Montand the role of Jean-Marc Clément, a superrich Frenchman who finds himself the subject of a Broadway play, in the film *Let's Make Love* (*Le Milliardaire* in France). Montand gave free rein to every aspect of his formidable talent; he also confirmed his reputation as *le french-lover* by seducing his co-star, Marilyn Monroe [3].

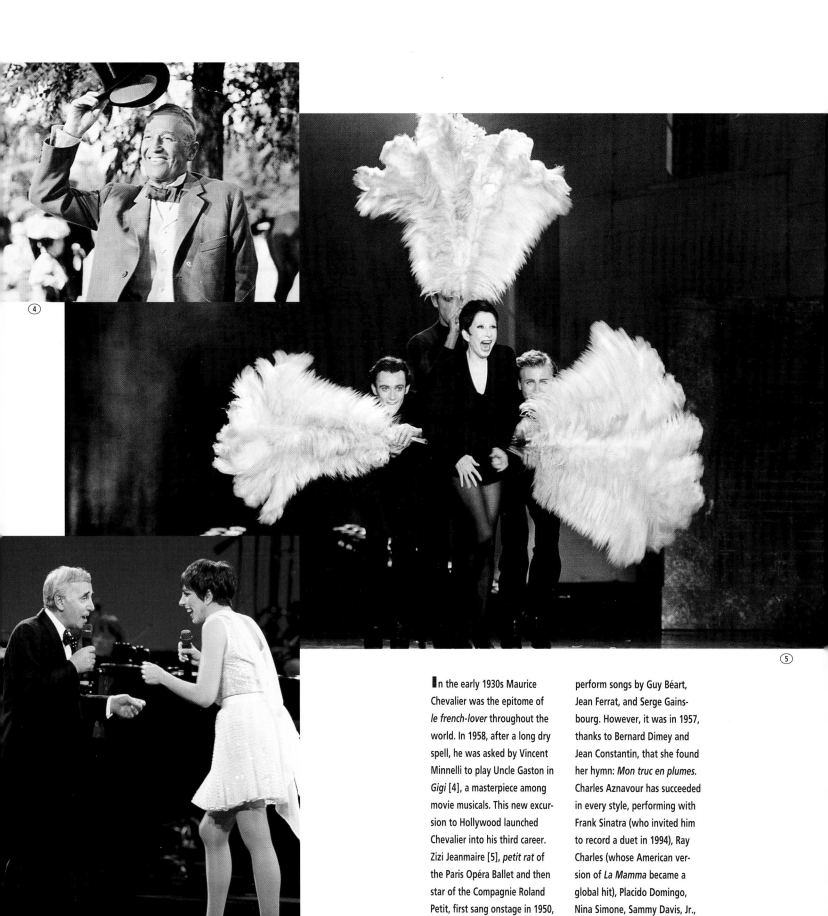

In the early 1930s Maurice Chevalier was the epitome of *le french-lover* throughout the world. In 1958, after a long dry spell, he was asked by Vincent Minnelli to play Uncle Gaston in *Gigi* [4], a masterpiece among movie musicals. This new excursion to Hollywood launched Chevalier into his third career. Zizi Jeanmaire [5], *petit rat* of the Paris Opéra Ballet and then star of the Compagnie Roland Petit, first sang onstage in 1950, the occasion being the title song of the ballet *La Croqueuse de diamants* composed by Raymond Queneau. Jeanmaire went on to perform songs by Guy Béart, Jean Ferrat, and Serge Gainsbourg. However, it was in 1957, thanks to Bernard Dimey and Jean Constantin, that she found her hymn: *Mon truc en plumes.* Charles Aznavour has succeeded in every style, performing with Frank Sinatra (who invited him to record a duet in 1994), Ray Charles (whose American version of *La Mamma* became a global hit), Placido Domingo, Nina Simone, Sammy Davis, Jr., Bing Crosby, and Liza Minnelli. Aznavour shared billing several times with Minnelli at the Palais des Congrès in Paris [6].

Jean-Paul Sartre [1] set to music by Kosma, for Gréco in 1950: *Rue des Blancs-Monteaux.* Pierre Prévert, filmmaker, and Jacques Prévert [2], the poet sung by Montand, Gréco, Mouloudji, et al. Elsa Triolet with Louis Aragon [3], whose poems became accessible to the public at large thanks to Jean Ferrat [4] primarily, but then also to Léo Ferré.

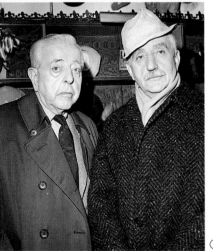

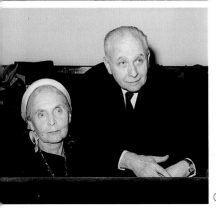

It may be a pleonasm to say that the lyrics to a song constitute a poem, but Trenet, Brassens, Brel, Ferrat, Ferré, Bécaud, and Aznavour, as well as many nonsingers, have written *chansons-poème.*

Just a few examples of poetic songs: *La Ballade irlandaise* by Eddie Marnay, *Syracuse* by Bernard Dimey, texts for numbers composed by Étienne Roda-Gil for Julien Clerc, by Jean-Loup Dabadie and Claude Lemesle for Reggiani, by Henri Contet or René Rouzaud for Piaf, by Jacques Plante for Aznavour, by Maurice Vidalin or by Louis Amade for Bécaud. In addition, there is the poem set to music, which then loses its original status and becomes a sublime song. Examples are the many poems by Prévert sumptuously wrapped in the melodies of Joseph Kosma, among them the unforgettable *Feuilles mortes.*

Charles Trenet has transformed the *sanglots longs,* or deep sobs, of Verlaine into popular songs. Georges Brassens gave us a magnificent song based on Francis Jammes's *La Prière.* Léo Ferré followed suit when he refashioned Apollinaire's *Le Pont Mirabeau* into a vocal line with orchestration. But the artist who has most often donned the poet's mantle is unquestionably Jean Ferrat. *Que serais-je sans toi* derives from a poem by Aragon set to music by Ferrat. I'm

even tempted to ask: What would Aragon be without Ferrat? A great poet, no doubt, but not a writer sung by the people. Thanks to Ferrat, Aragon's texts are known all over the world, and without Ferrat, they would probably have an audience limited to France.

A song is very often born of a text written in rhyming verse according to the rules of both prosody and metrics, always with alternating masculine and feminine terminals. I, too, have many times exploited the formula, but music already composed has also provided the ambiance or idea I needed.

Michel Sardou invariably begins with a text, and a good thing too, given that his composer, Jacques Revaux, prefers to discover his music in the lyrics. On the other hand, Michel Fugain composes first, without reference to words. Not Gilbert Bécaud, who loves to take his inspiration from a text. Georges Brassens wrote the words first, while simultaneously sketching the musical accompaniment.

A beautiful poem that sings, even without music, can only be enhanced by an inspired melody, a clever combination of notes in perfect harmony with words. Such is the case in Trenet's collaboration with Verlaine, which gave us that splendid masterpiece *Verlaine*.

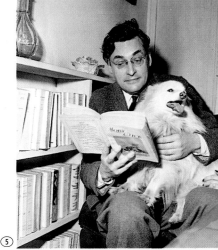

⑤

⑥

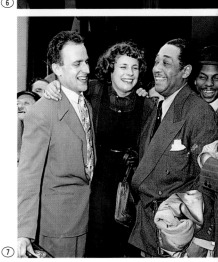

⑦

Raymond Queneau [5] set to music by Kosma for Gréco: *Si tu t'imagines.* Jean Cocteau [6, left] wrote for Marianne Oswald. Paul Fort [6, right] set to music by Georges Brassens [6, center]: *Le Petit cheval.* Boris Vian [7] in the company of Duke Ellington.

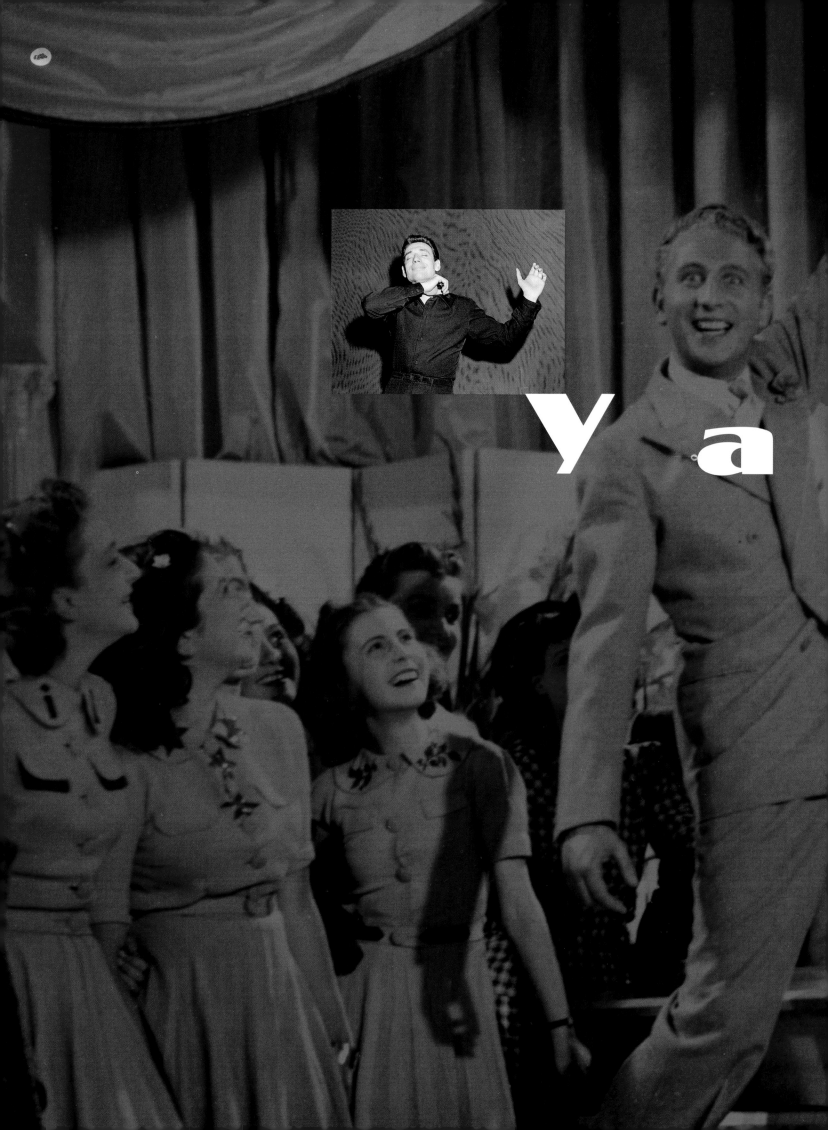

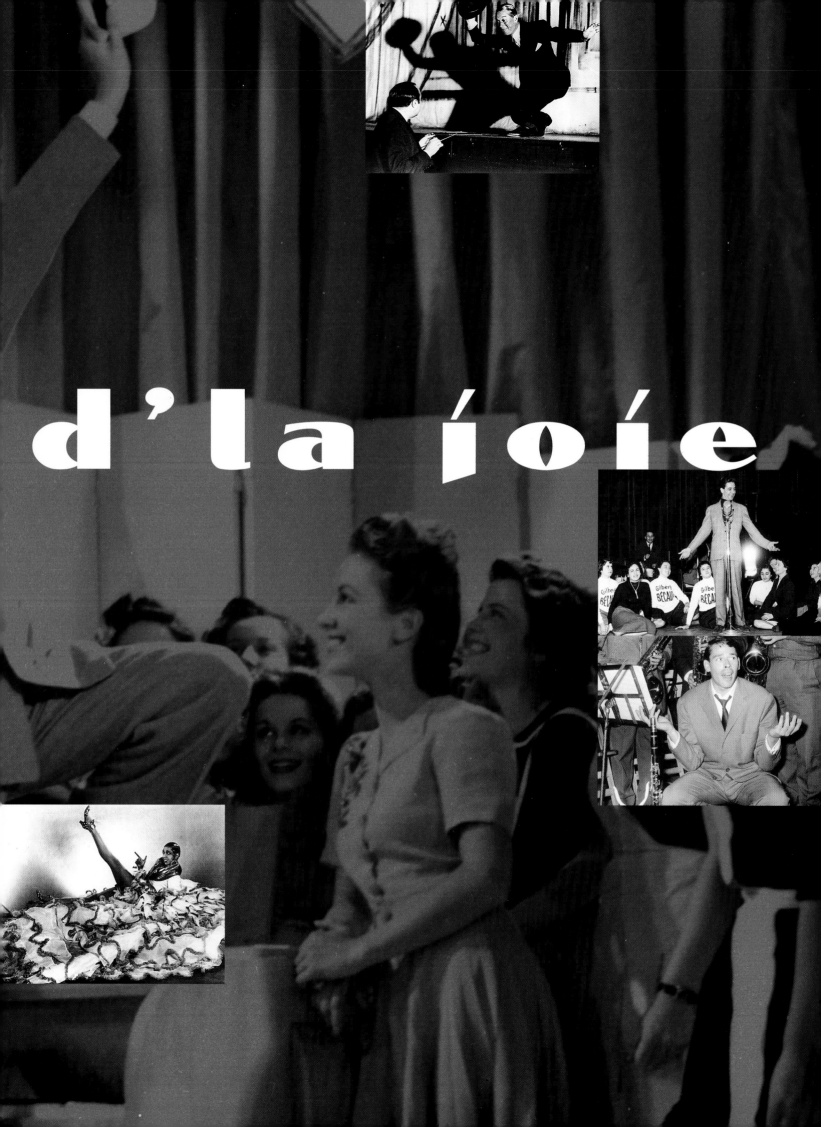

d'la íoíe

①

②

What better title could there be for a chapter on happiness? Perhaps only Beethoven's *Hymn to Joy.* Song offers one of the surest ways to express a natural feeling which, alas, comes all too seldom. Last night I watched my 21-month-old granddaughter Claire as she lay in bed singing and laughing. The first utterings of a baby, but they resembled a song of joy. The sources of bliss are many: love; an unexpected encounter between two old friends; the collective excitement of fans at a sporting event; the somewhat alcoholic cheer of colleagues at a banquet; the warm memory of communal life in the army or at work; the pleasure of a family ritual such as marriage, baptism, first communion, or anniversary. There is also the slightly artificial joy that comes with a national or religious holiday, triggered, for example, by caroling at Christmas or the patriotic hoopla of Bastille Day. But gladness also has figured large in the hit songs of the biggest stars.

Once again it's Charles Trenet who sets the tone, this time in *Je chante.* Here we have rapture at its purest: "I sing for a bit of bread, I sing for a bit of water." *Nationale 7,* by the same writer, is also a song of joy: "National 7, highway of holidays, take it, whether we number five, six, or seven." *Le Jardin extraordinaire, À la porte du garage, La Route enchantée, Boum.* Charles Trenet incarnates the joy of being of alive, the joy of making music.

Maurice Chevalier, who, too, sang *Y d'la joie,* knew what it was to be jubilant: *"Les gars de Ménilmontant sont toujours remontant."* Prosper is another gay blade, after his guttersnipe fashion.

The words "Parisian music hall" have long signified joy, good humor, and frivolity. Tourists, always attracted by fantasies of "Gay Paree," come looking for the ghost of Mistinguett [1], who, as far back as 1897, was a nightly sensation at L'Eldorado. Arriving as a little tart, she left in 1907 ready to become a star. And so she was two years later, at the Moulin Rouge, where, in the arms of Max Dearly, she created *La Valse chaloupée.*

Maurice Chevalier (here [2] in London in 1935) was voted the most popular star in the world, by the Americans no less. This *gosse de Paris* knew enough to speak English with an irresistible French accent, thereby emerging as the official ambassador of Parisian gaiety and charm, the export product *sans pareil.*

Charles Trenet [3] made *joie* rhyme with *folie,* beginning in 1937, with *Je chante,* a piece written during military service— while in the brig! In this astonishing song, evident gaiety all but obscures the suicide at the end. Notwithstanding, the whole of Trenet's oeuvre radiates youth and ebullience.

Lyrics : Charles Trenet ▪ **Music** : Charles Trenet and Michel Émer, 1938

Y'a d' la joie, bonjour bonjour les hirondelles
Y'a d' la joie, dans le ciel par-dessus le toit
Y'a d' la joie et du soleil dans les ruelles
Y'a d' la joie, partout y'a d' la joie.

Tout le jour, mon cœur bat, chavire et chancelle
C'est l'amour qui vient avec je ne sais quoi
C'est l'amour, bonjour bonjour les demoiselles
Y'a d' la joie, partout y'a d' la joie.

Le gris boulanger bat
La pâte à pleins bras
Il fait du bon pain, du pain si fin
Que j'ai faim.
On voit le facteur qui s'envole là-bas
Comme un ange bleu
Portant ses lettres au Bon Dieu.

Miracle sans nom, à la station Javel
On voit le métro qui sort de son tunnel
Grisé du ciel bleu, de chansons et de fleurs
Il court vers le bois, il court à toute vapeur !

Y'a d' la joie, la tour Eiffel part en balade
Comme un' folle ell' saute la Seine à pieds joints
Puis elle dit : « Tant pis pour moi si j' suis malade !
J' m'ennuyais toute seule dans mon coin ! »
Y'a d' la joie, le percepteur met sa jaquette,
Plie boutique et dit d'un air très doux, très doux :
« Bien l' bonjour, pour aujourd'hui finie la quête.
Gardez tout ! Messieurs, gardez tout ! »

Mais soudain voilà, je m'éveille dans mon lit.
Donc, j'avais rêvé, oui car le ciel est gris
Il faut se lever, se laver, se vêtir
Et ne plus chanter si l'on n'a plus rien à dire.
Mais je crois pourtant que ce rêve a du bon
Car il m'a permis de faire une chanson
Chanson de printemps, chansonnette d'amour
Chanson de vingt ans, chanson de toujours.

Y'a d' la joie, bonjour bonjour les hirondelles
Y'a d' la joie, dans le ciel par-dessus le toit
Y'a d' la joie et du soleil dans les ruelles
Y'a d' la joie, partout y'a d' la joie.

Tout le jour, mon cœur bat, chavire et chancelle
C'est l'amour qui vient avec je ne sais quoi
C'est l'amour, bonjour bonjour les demoiselles
Y'a d' la joie, partout y'a d' la joie.

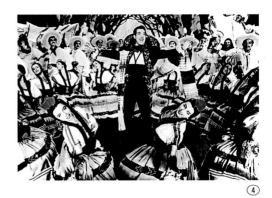

④

Operetta is the theatre of happiness par excellence. Luis Mariano [4], with his magnificent voice and Latin-lover physique, became the king of the genre. In 1950, during the run of *Chanteur de Mexico*, the Mariano fan club claimed to have 16,000 members and to have distributed 800,000 photographs to the star's admirers.

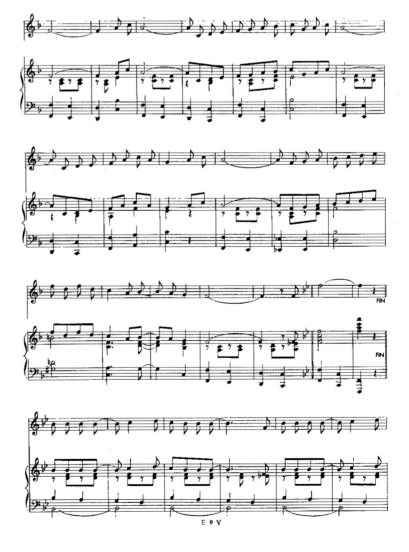

③

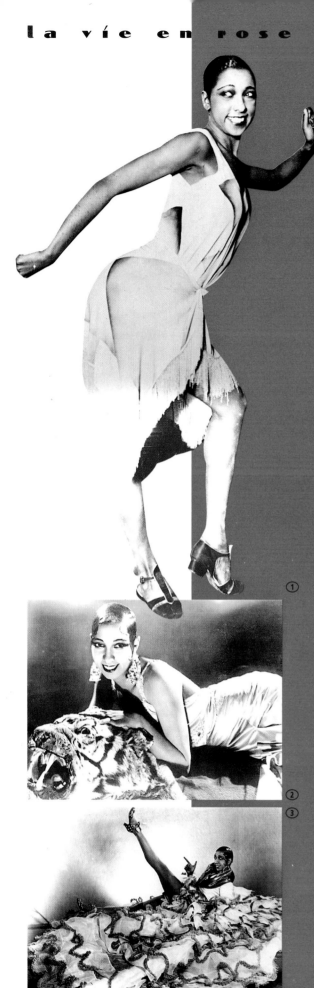

The titles of Maurice's songs speak for themselves: *Ça sent si bon la France*, a gleeful song written in 1941 during the darkest years in the history of France. *Valentine*, on the other hand, parodies love songs, exuding characteristic French earthiness. *Ma pomme: "C'est moi je suis plus heureux qu'un roi"; La chanson du maçon; Le chapeau de Zozo; Quand un Vicomte*. All abound in jingling couplets sure to fill hearts with a touch of gaiety, especially in *Tout va très bien Madame la marquise, Qu'est-ce qu'on attend pour être heureux, Ça vaut mieux que d'attraper la scarlatine*. It's worth noting that 1938 and 1940 were years particularly rich in happy tunes. Just think of *Boum* and *Ça fait boum*. And indeed *boum* would not be long in coming. *La Route enchantée, La Polka du roi, Sur deux notes, Un petit air, Et tout ça fait de l'excellent français, Comme de bien entendu, Je suis swing, Le Soleil a rendez-vous avec la lune* . . . and the world below a rendez-vous with bombs.

Que la France est belle, L'Hôtel des trois canards, On prend le café au lait au lit . . . provided any could be found. *Parlez-moi du printemps*, particularly the spring of 1940! Along with the historic songs and songs of engagement, we could also write a history of songs as *faux-pas*.

Not to be forgotten, even as they recede in time, are those stalwarts of the Belle-Époque *caf'conc*—Félix Mayol, with his *méridional* zest, or Vincent Scotto, another troubadour from the South, whose sunny clime he never ceased to celebrate, or Alibert and his signature number *Au soleil de Marseille*, or that other *marseillais*,

Fantasy sometimes rolls into folly. When Josephine Baker first came before the public, she dared to lace humor with a touch of indecency. Even in the Roaring Twenties, the overtly erotic could trigger scandal, a factor contributing to the success of the black American goddess [2]. "We should be happy for a chance to admire this entirely nude young woman with her short, shingled hair, extraordinary curves, and neat, firm, gyrating belly" *(Paris-Soir)*. Whenever Josephine danced to the point of flying apart—the Charleston, the Black Bottom, or some unknown bit of choreography—middle-class France went into shock, an effect the artist would successfully exploit throughout her long career [1]. Indeed, Josephine evolved into a Parisian institution, a reference point for every new trend. She became the star attraction of a cabaret, Chez Joséphine, and in 1927 she took top billing at the Folies-Bergère in an aptly titled review: *Un vent de folie* [3].

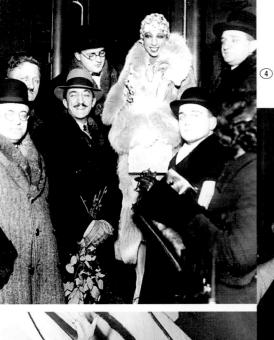

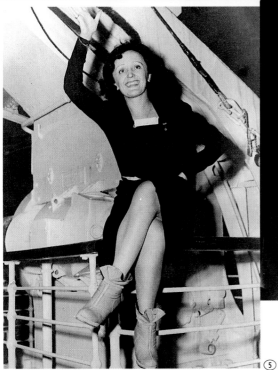

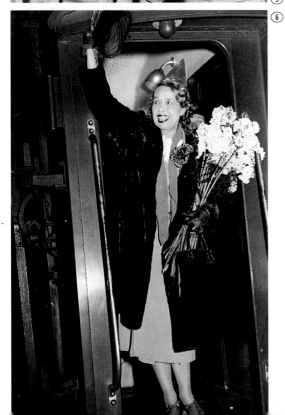

The whole world wanted to meet the "Black pearl." After her sensational debut at the Théâtre des Champs-Élysées in September 1925, Josephine Baker toured 25 countries in two years. Here she's seen making her historic entrance into Vienna [4], where the city was flooded with tracts denouncing the "black goddess." Armed guards escorted La Baker to her hotel, all the while that a petition was being circulated demanding the prohibition of "pagan dances." The Austrian parliament even debated the issue, thanks to a deputy scandalized that a good number of citizens would pay 100,000 shillings to feast their eyes on nudity, all the while that 100,000 penniless strikers were wandering the streets of Vienna. When Édith Piaf arrived in New York on the *Queen Elizabeth* [5] in October 1947, or when Mistinguett went on a world tour (here [6] in 1939), or yet when Maurice Chevalier visited a London hat factory in 1935 [7], or just went about his work [8]—none of them encountered hostility and rejection. They could simply radiate the charm and fantasy always associated with Paris.

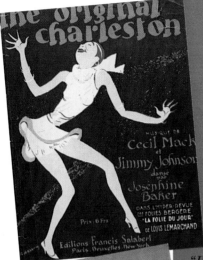

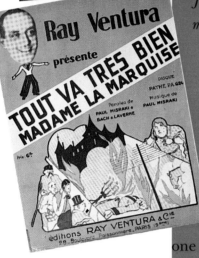

Andrex, who made a career of imitating Chevalier, joyously rendering *"Chez Bébert le monte en l'air."* The much-loved Georges Milton, who became the "king of the gate-crashers" in one of the first French talking films *(Le Roi des resquilleurs)*, made a smash hit with that celebratory line: *"J'ai ma combine, jamais rien dans la vie ne me turlupine."*

It's been a struggle, since the Existentialist heyday of Saint-Germain-des-Prés and the Rue Mouffetard, to recapture that tone of irrepressible optimism so characteristic of the decades before World War II. René-Louis Lafforgue and Bobby Lapointe managed to endow a few postwar years with their special brand of ebullience—the one in *Julie la Rousse* and the other in *Avanie et framboise*—only to expire well before their time.

Annie Cordy specialized in whimsy spiked with jocosity, all fully evident in *Cigarettes Whisky et ptites pépés, Fleur de papillons,* and many other sparkling numbers. Meanwhile, Patachou, the *diseuse* of Montmartre, offered *La Bague à Jules* by Jamblan and Siniavine. Also shining in an eclectic repertoire was Philippe Clay, who borrowed from all the best songwriters. And not to be forgotten are *Si tu vas à Rio* sung by Dario Moreno, *Brigitte Bardot* brought to glittering life by Bob Azzam, and *Scoubidou* by Sacha Distel and Maurice Tézé.

Georges Brassens cultivated irony until it verged on the comic, but he rarely wrote songs that could be deemed unabashedly gay. So, too,

With her hip-swinging Charleston, Josephine announced a radical transformation in French attitudes [1]. Misraki, Bach, and Lavergne's *Tout va très bien madame la marquise,* popularized by Ray Ventura and his Collégiens [2], narrates how a Marquise learns of the death of her gray mare, the destruction of her château by fire, and the suicide of her husband. In these catastrophes, all treated with stoicism and black humor, the French discovered a song symbolic of their own plight during the 1930s. In 1937 Maurice Chevalier [3] introduced *Y'a d'la joie* whose author, Charles Trenet [4], emerged as the spokesman of a generation for which life began in national defeat.

Jacques Brel, who mingled genres without ever crying *"Ya d'la joie,"* for the simple reason that he sought none. Nevertheless, the Belgian composer/singer made a few excursions into comedy, *Les Bonbons* being an example. Gilbert Bécaud, in *Salut les copains, Les Cerisiers sont blancs, L'Important c'est la rose, L'Enterrement de Cornelius,* and *Le Jour où la pluie viendra,* proved to be decidedly more upbeat than either Brassens, Brel, or their followers. Among these, Léo Ferré invested bitterness with nostalgia and even aggression, as did Barbara, Claude Nougaro, Serge Gainsbourg, and the other big names of the sixties, seventies, and eighties, who would never be known for euphoric merriment. Gérard Lenorman, in *Si j'étais président* and *La Ballade des gens heureux,* allowed joy a bit more rein, along with Michel Fugain, the latter in *La Fête* and *Chante comme si tu devais mourir demain.* Joe Dassin—another performer who barely made it beyond forty—regaled us with *La Bande à Bonnot, La Complainte de l'heure de pointe, L'Équipe à Jojo, Billy le bordelais, Le Petit pain au chocolat.*

Also among the short-lived was Claude François, whose repertoire abounds in rhythmic refrains and *joie de vivre,* particularly his last and probably greatest success, *Alexandrie Alexandra.* And Pierre Perret's *Le Zizi* is one of the funniest songs ever written. Indeed, Perret is the ultimate *rigolo,* cases in point being *Le Tors-boyau* and *Dépêches-toi mon amour.*

The 1930s saw the advent of the French crooner, beginning with Tino Rossi, who scored at the Casino de Paris in *Parade de France* in 1934, followed by Marie Dubas, the creator of *Fanion de la légion* and *Mon Légionnaire,* both by Raymond Asso and Marguerite Monnot in 1936. "[Marie] is my model, the example I wanted to follow," declared Édith Piaf. Meanwhile, Yves Montand was making his debut in Marseilles. With Fred Astaire as his model, he sang the hits of Trenet and Chevalier, as well as *Dans les plaines du Far-West,* a song composed for him by Charles Humel.

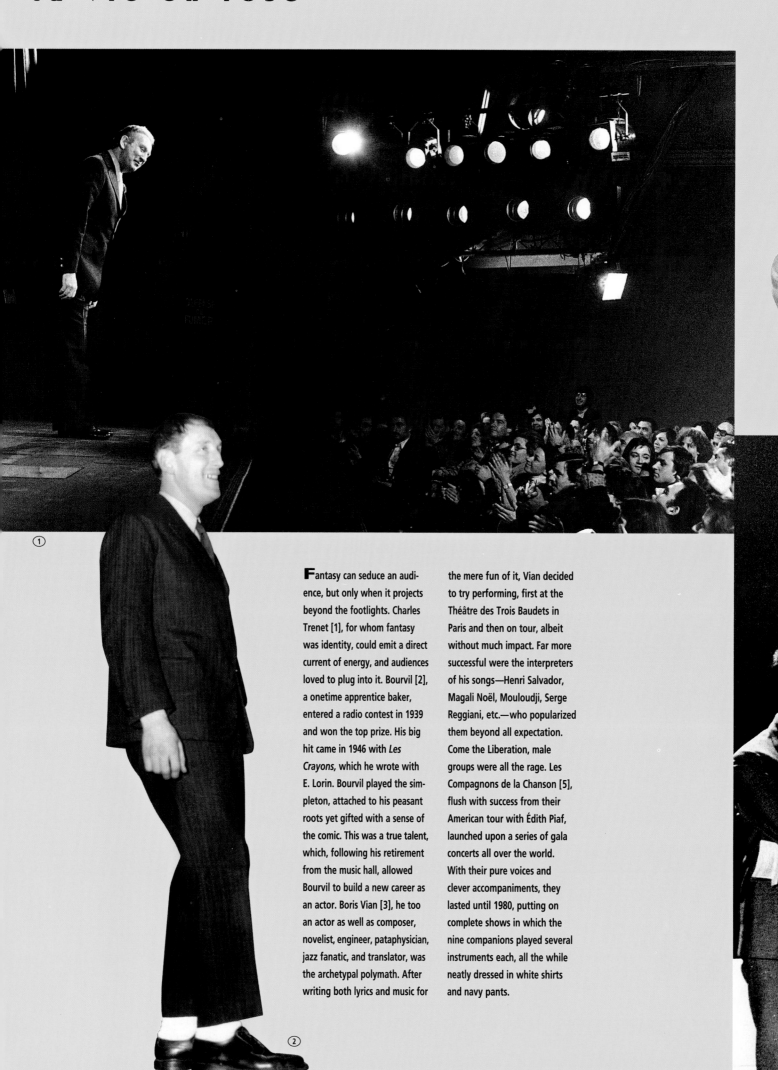

① ②

Fantasy can seduce an audience, but only when it projects beyond the footlights. Charles Trenet [1], for whom fantasy was identity, could emit a direct current of energy, and audiences loved to plug into it. Bourvil [2], a onetime apprentice baker, entered a radio contest in 1939 and won the top prize. His big hit came in 1946 with *Les Crayons,* which he wrote with E. Lorin. Bourvil played the simpleton, attached to his peasant roots yet gifted with a sense of the comic. This was a true talent, which, following his retirement from the music hall, allowed Bourvil to build a new career as an actor. Boris Vian [3], he too an actor as well as composer, novelist, engineer, pataphysician, jazz fanatic, and translator, was the archetypal polymath. After writing both lyrics and music for the mere fun of it, Vian decided to try performing, first at the Théâtre des Trois Baudets in Paris and then on tour, albeit without much impact. Far more successful were the interpreters of his songs—Henri Salvador, Magali Noël, Mouloudji, Serge Reggiani, etc.—who popularized them beyond all expectation. Come the Liberation, male groups were all the rage. Les Compagnons de la Chanson [5], flush with success from their American tour with Édith Piaf, launched upon a series of gala concerts all over the world. With their pure voices and clever accompaniments, they lasted until 1980, putting on complete shows in which the nine companions played several instruments each, all the while neatly dressed in white shirts and navy pants.

③

④

Unlike Les Compagnons de la Chanson, Les Frères Jacques [4] belonged to theatre more than to the music-hall tradition. Dressed in white gloves and a kind of body stocking designed by Jean-Denis Malclès, they used all manner of accessories to create a context for their songs. The "brothers" borrowed from both mime and acrobatics and explored every aspect of humor, from satire to poetry. Until 1980 they played all over the planet, giving dynamic, quicksilver performances in which every entrance, exit, gesture, and lighting effect was in fact carefully studied.

⑤

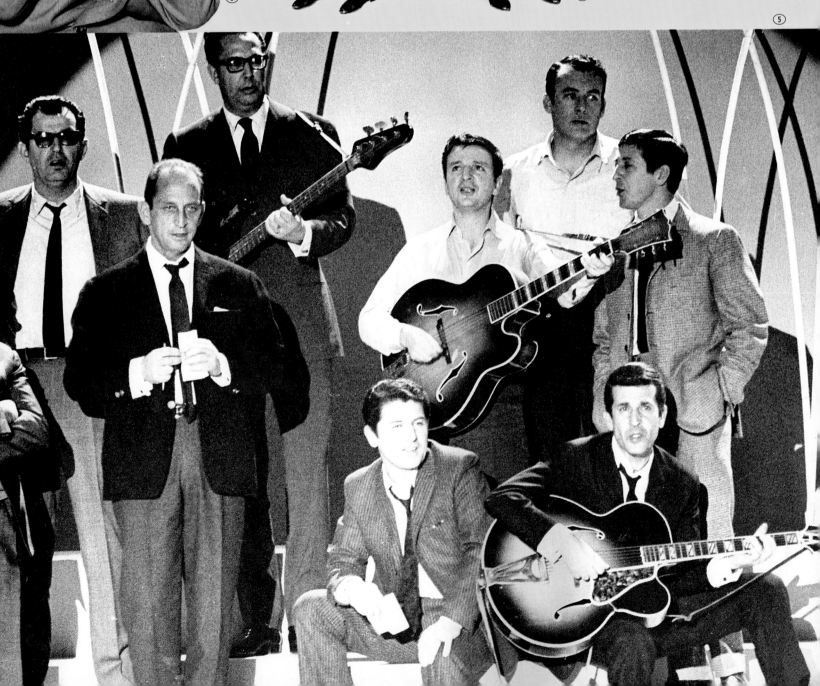

(1)

(2)

(3)

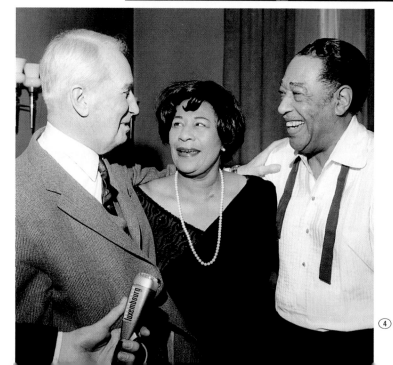

(4)

The material may be dramatic, but the popular singer should never stop smiling. On 12 October 1961, after a last-minute cancellation by Marlene Dietrich, Bruno Coquatrix offered the Olympia stage to Jacques Brel [1], an author/composer/singer with a talent for writing songs, even if their interpreters had yet to move the public. In one evening, Brel became a star, proving himself to be an extraordinary man of the theatre.

On 3 December 1946 Les Portes de la nuit [2], a film directed by Marcel Carné and written by Jacques Prévert, opened at the Cinéma Marignan. The role of Diégo was to have been taken by Jean Gabin, while Malou was supposed to possess the face of Marlene Dietrich.

Instead, the actors were Nathalie Nattier and Yves Montand. Montand had just completed his first singing engagement at the Théâtre de l'Étoile, where he benefited from the support of Édith Piaf. Georges Brassens, a poet of considerable erudition, never denied his love of popular verse, and often sang the songs which had moved or influenced him, among them the works of Jean Tranchant, Mireille and Jean Nohain, and Charles Trenet. Here [3] Trenet and Brassens find their mutual regard something to smile about backstage at the Théâtre de l'Étoile in 1961.

In 1966 when Ella Fitzgerald and Duke Ellington joined for a concert at the Salle Pleyel [4], they were greeted by the comedian Momo (Maurice Chevalier).

(5)

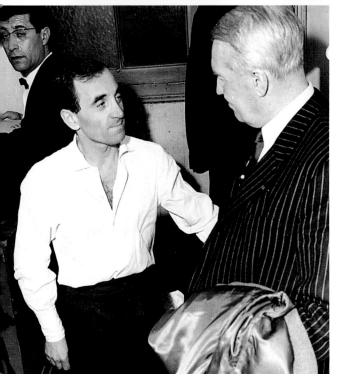

(6)

(7)

When Johnny Hallyday and Gilbert Bécaud arrived to congratulate Jacques Brel [5] at the Olympia in 1961, the scene was truly a Mount Olympus of French song. Three men, with three approaches and three distinct talents, yet each was the incarnation of popular art. Chevalier, the patriarch, liked to keep up with the next generation. Always on the lookout, he listened, frequented the music halls, and never hesitated to offer a word of advice. While congratulating Aznavour after the latter's Olympia concert in 1965, Chevalier knew he was in the presence of his successor.

"I live in Saint-Germain-des-Prés . . . ," wrote and sang Léo Ferré, after which Henri Salvador [7] took up the song and, with his guitar and crooner's voice, paid one of the most beautiful tributes to a quarter deeply symbolic of the Parisian spirit in the years following the Liberation of 1944.

Gilbert Bécaud [8], the first French singer to make the young Olympia audience break up the furniture, made his debut in 1954, turned on the power, and launched upon a brilliant career. "Monsieur 100,000 Volts" electrified audiences all over the world. He explored every kind of song, doing so with utter mastery and a showmanship that would influence several generations.

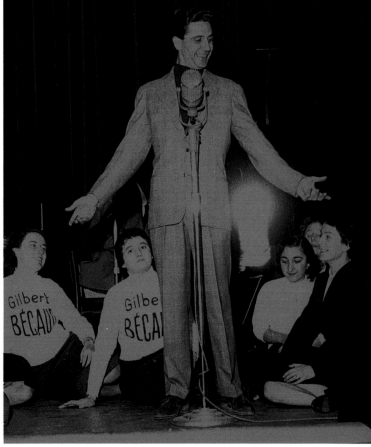

(8)

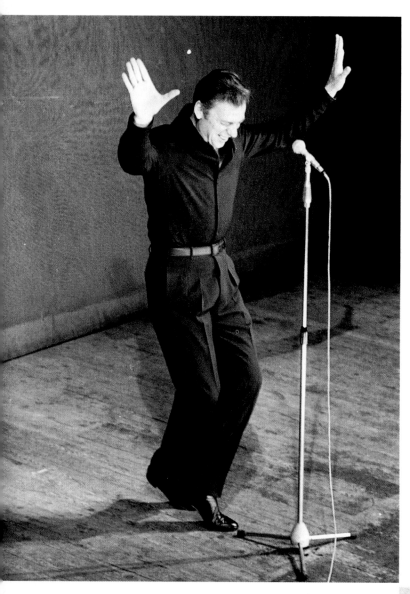

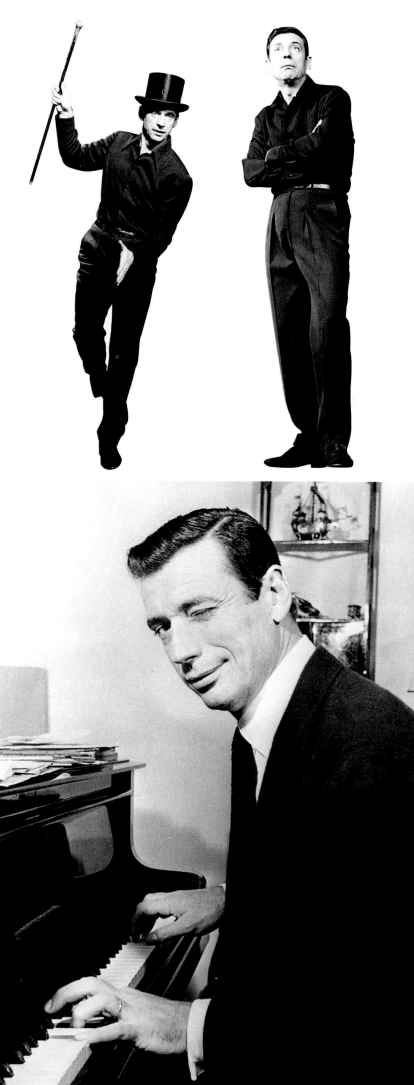

With his sly little *héhés*, or sometimes with thunderbursts of César laughter, Yves Montand not only punctuated certain songs, he also declared the spirit of men willing to clench their fists in the name of liberty. From the start, this son of Italian immigrants pursued his career with exceptional energy and strength. In 1944, a bowled-over Édith Piaf offered him the first half of her program at the Théâtre de l'Étoile. The following year, on the same stage, the young man from Marseilles had a veritable triumph in a run of performances that continued for seven weeks. Voracious and perfectionist, Montand always found ways to stretch himself, taking on ever greater risks—theatre, movies, and music hall. He learned to generate enthusiasm by the theatrical effects of his performances as well as by the quality of his songs. Increasingly he offered the public a very broad palette: the ambition of an interpreter of poets (*"Barbara quelle connerie la guerre"*), the longing of a man in love with love (*"C'est une chanson qui nous ressemble moi qui t'aimais toi qui m'aimais"*), the satisfactions of an entertainer (*"C'est si bon"*), etc.

the wit of Montand

Montand, the only artist capable of theatrical marathons, with Paris runs of six sold-out months, found himself criticized for the sheer perfection of his performances. Every gesture, effect, and spotlight was thought out and rehearsed, causing some to sense a want of feeling, surprise, or personal involvement, a fear of breaking free. Others—and they were legion—simply allowed themselves to be carried away by the charm, by the Montand voice and magic. As Jacques Prévert wrote: "A red curtain rises in front of a black curtain. Before this black curtain, Yves Montand, with the mere look in his eyes, the brilliance of his smile, the movements of his hands, the dance of his feet, provides all the scenery required. Scarcely is he on stage when the audience is out of this world"

Serge Gainsbourg [2] gave short shrift to received ideas, a kick in the pants to conformism, and the back of his hand to fashion. Refrains such as *Aux armes etc.*, *Je t'aime moi non plus*, *Poupée de cire poupée de son*—all chiseled with surgical care and aimed with the precision of poisoned darts—provoked enthusiasm and scandal.

The history of French song reflects the rebellious spirit of a people enamored with freedom and incapable of respect for authority. Jacques Brel [1] loved to portray individuals rendered absurd by their own meanness and self-importance. In *L'Air de la bêtise,* he even fashioned a long aria in the style of grand opera as part of his campaign to castigate stupidity.

Léo Ferré [3] berated the everyday baseness of his era. Casting himself as the *poète maudit*—the caustic anarchist—he despised politics and the political class, denouncing even militants. The fulminations of his writing placed him in the front rank of society's scourges, and numerous would be the author/composers of later generations who took him as their model.

Jean Ferrat [4] always anchored his humor in social reality, chiding complacent attitudes and the abuses of authority. Planting himself squarely outside the system, he remained a unique phenomenon on the variety stage. Finally, he retired to the Ardèche, refusing to appear on stage but continuing to record. Each of his recordings is an event, a bestseller beyond all precedent.

(5)

(6)

Troublemakers among France's singers and songwriters exploit the language's richness, always in the hope of rattling the bourgeoisie. And word play is an exercise in style much prized by the public. Boby Lapointe [5] was a master of the art. A mathematician, he approached songwriting with scientific rigor, inventing formulas that hit the mark: *"Elle était Antibaise . . . moi qui serais plutôt pour. . . ."* The words sprang to life, and the author became a sort of cult figure for the discriminating public, while the media pegged him a singer for the intelligentsia. Boby Lapointe was a genius who died unknown to the general public.

Pierre Perret [6], beginning in 1958, seduced the audience with the freshness of his language, a language flirting with argot and spiked with sharp images. He told stories, often about sordid people, with the saving grace of humor. Bold in his choice of themes, Perret broke all sales records with his fiery bolts: *"Tout, tout, tout, j'vous dirai tout sur le zizi"* His images became proverbs, taken up and circulated in the street. *Cuisse de mouche, Les jolies colonies de vacances, Tonton Christobal,* etc., remain verses passed on from generation to generation.

Never before Georges Brassens [7] did anyone use such coarse language in variety theatre, nor had anyone ever dared say *"la musique qui marche au pas, cela ne me regarde pas."* Further, no one had narrated stories like *Le gorille* or *Hécatombe.* Brassens did not have to wait long before hearing from the guardians of moral order; meanwhile, the public delighted in a troubadour brave enough to speak for it with both talent and truculence.

(7)

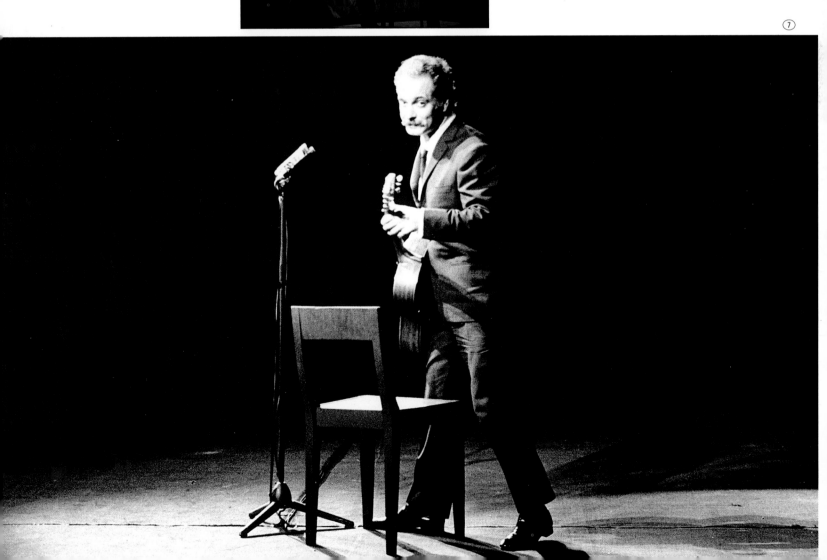

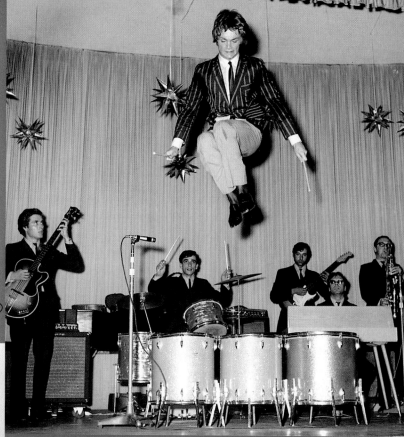

Come the 1960s, fantasy or whimsy would thrive more in form than in substance. The new idols were those who appealed to the teenage baby-boom generation, which meant keeping things light. A major theme was love, of course, but chaste and frequently hapless. The songs, often naïve and sometimes silly, benefited from multiple interpretations, as when both Dalida, the sulfuric Mediterranean, and Johnny Hallyday, the quintessential French rocker, performed *24,000 baisers, T'aimer follement,* and *Itsi Bitsi Bikini.* Claude François [3 and 4] treated love in his characteristically tender, adolescent manner. His originality lay more in rhythm and melody than in lyrics. Inspired by African-Americans, François mounted shows in which dance and visual effects counted for as much as the songs.

Humor remained the province of the elders. Thus, Henri Salvador [2], with a twenty-year career behind him, brought the 1960s a touch of televisual foolery. He even produced his own TV shows—*Salves d'or*—in which he doubled words with images.

During the 1960s French television had a huge impact on the popular song. It offered numerous variety shows and admitted every kind of form. Among the creators of audiovisual shows, one outstanding talent was Jean-Christophe Averty, who worked with both precision and invention, carefully planning productions before shooting them. Each song had an ambitious and carefully wrought scenario. Playing with acid humor and the polarities of black and white, Averty made it all work by bringing in the biggest stars, such as Yves Montand [5]. In 1964 the great Marseillais joined Averty for a production that remains one of the happiest moments in the marriage of television and popular song.

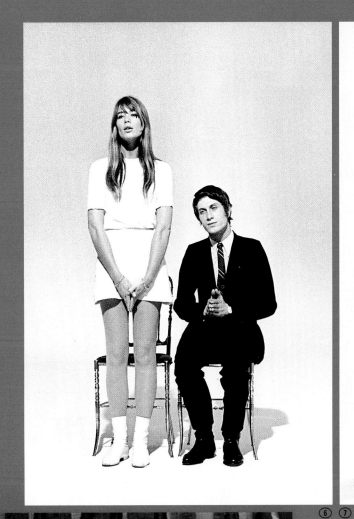

⑥ ⑦

Once a new musical wave rolls in, important changes usually follow in its wake. The 1960s proved to be a turning point in the evolution of behavior, style, and body language. The new stars took their lead from the most turbulent of the elders, such as Charles Aznavour, seen here at the Moulin Rouge in 1955 [8]. At the same time, they also reveled in derision and modernity. Françoise Hardy, the intellectual within the yé-yé family, married Jacques Dutronc, the elf of the second half of the 1960s. The couple [6] came to symbolize the youth movement. They were both good-looking, intelligent, cultivated, and masters of winking irony. As for Nino Ferrer [7], a mad exponent of "rhythm and blues," he dressed in keeping with the nutty things he wrote, some of which immediately lodged in the collective memory: *Oh hé hein bon, Z'avez pas vu Mirza?, Gaston y'a l'téléfon qui son.*

⑧ ▲

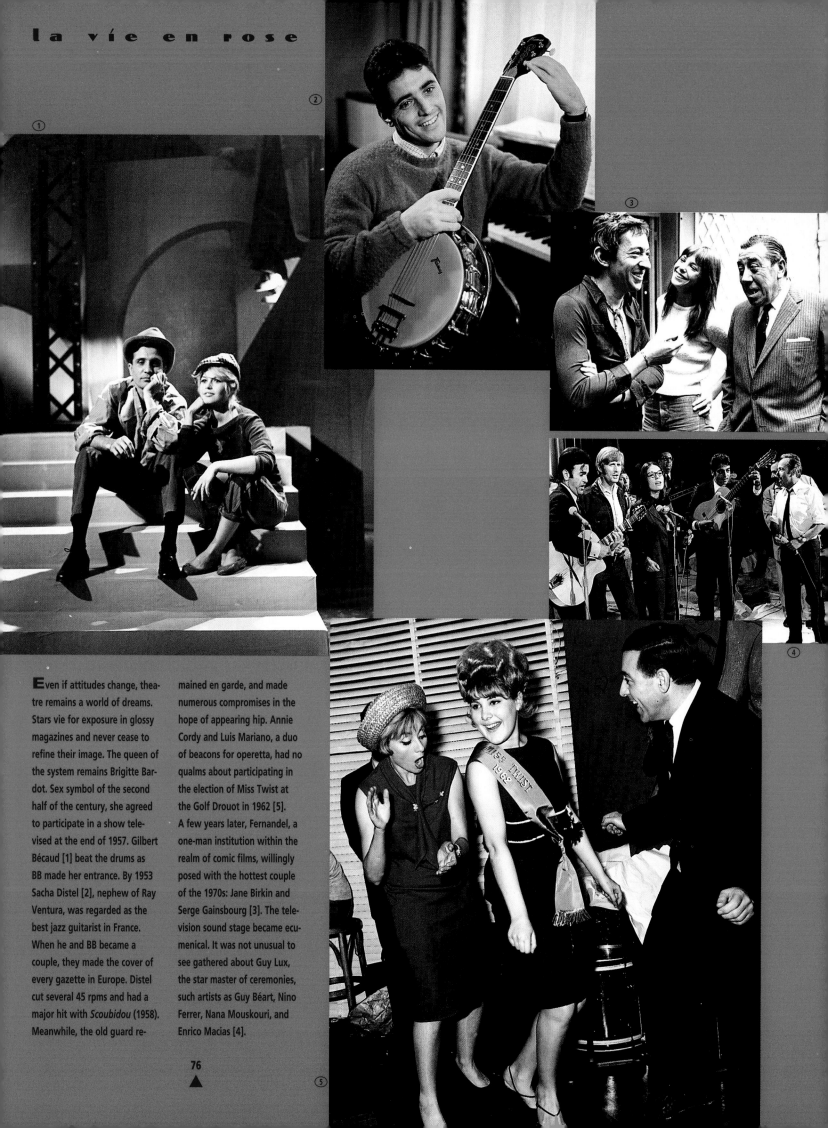

Even if attitudes change, theatre remains a world of dreams. Stars vie for exposure in glossy magazines and never cease to refine their image. The queen of the system remains Brigitte Bardot. Sex symbol of the second half of the century, she agreed to participate in a show televised at the end of 1957. Gilbert Bécaud [1] beat the drums as BB made her entrance. By 1953 Sacha Distel [2], nephew of Ray Ventura, was regarded as the best jazz guitarist in France. When he and BB became a couple, they made the cover of every gazette in Europe. Distel cut several 45 rpms and had a major hit with *Scoubidou* (1958). Meanwhile, the old guard re-mained en garde, and made numerous compromises in the hope of appearing hip. Annie Cordy and Luis Mariano, a duo of beacons for operetta, had no qualms about participating in the election of Miss Twist at the Golf Drouot in 1962 [5]. A few years later, Fernandel, a one-man institution within the realm of comic films, willingly posed with the hottest couple of the 1970s: Jane Birkin and Serge Gainsbourg [3]. The television sound stage became ecumenical. It was not unusual to see gathered about Guy Lux, the star master of ceremonies, such artists as Guy Béart, Nino Ferrer, Nana Mouskouri, and Enrico Macias [4].

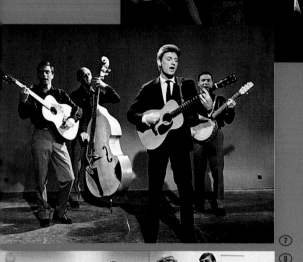

⑥

⑦

⑧

Radio and television attempt to provide space for hopes. Mireille's Petit Conservatoire de la Chanson (here [8] in 1967) became a window to glory for a whole population of budding stars. Each week brought a new lineup of young folk eager for a chance, only for many of them to be summarily dismissed, while a few caught the head mistress's attention. We have only to remember that Ricet-Barrier, Jean-Jacques Debout, Françoise Hardy, Alice Dona, and Yves Duteil all graduated from the Petit Conservatoire.

⑩

Youth's consumer power, particularly in the 1960s, affected every facet of life, most particularly variety theatre. Unknowns became overnight sensations, some of them devoid of experience and merely the beneficiaries of general madness. However, when Hugues Aufray [7] finally hit his stride, it was not without a long trial. Following years of galley service and a journey to the United States, he returned with his "skiffle-group" (an all-string ensemble) and a repertoire based on folklore—campfire songs mixed with adaptations from Bob Dylan.

In 1967 all of France took up the chorus *"Tagada tagada voilà les Daltons,"* the refrain that catapulted Joe Dassin [9] into the Olympia of stars. Still, the blow-out event of the year was the joint concert given in March by Johnny Hallyday and Sylvie Vartan [6], announcing they were tying the knot of perfect love. When the couple recorded *"J'ai un problème, je crois bien que je t'aime,"* it became a major hit.

As a solo act, Claude Ciari, the guitartist with the Champions, became a huge star in Japan. He also composed an international hit: *La Playa.* Even so, Ciari likes to rejoin his old friends—Michèle Torr, Adamo, Eddy Mitchell, and Richard Anthony [10]—for an occasional *boeuf* (jam session).

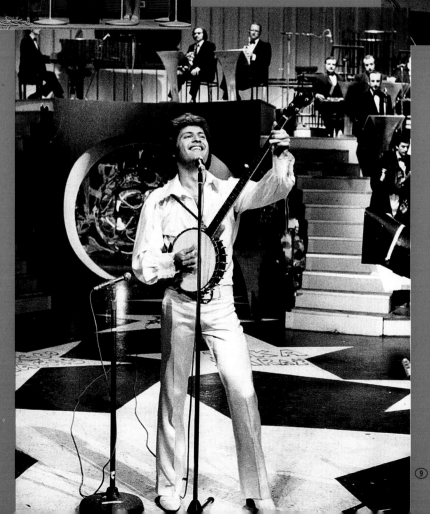

⑨

②

①

③

The important thing for an artist is longevity. Music hall is a merciless world that tolerates neither mistakes nor complacency. Michel Fugain [1] made his first record in 1966. After the success of *Prends ta guitare, chante avec moi* (Jourdan/ Fugain) and, most of all, *Je n'aurai pas le temps* (Delanoë/ Fugain), his career went into a slump. Then, dipping into his unique experiences, he came up with a hit—*Big Bazar*—a production that included thirteen actors, singers, and dancers. Fugain then left to direct an educational center for artists in the South of France, again made it to the hit parade, fell into further, even longer, slumps, and finally groped his way back to success. On 14 July 1996, in La Rochelle, he celebrated the first three decades of his career.

Since 1957, Pierre Perret [2] has enjoyed an uninterrupted stream of success. One hit follows another, just as the tours sell out regularly without ever a serious bump in the road. Needless to say, Pierre Perret (here at the Casino de Paris in 1993) has managed his career with exemplary intelligence and wisdom. Smart enough to retire from the scene long enough to make himself all the more desirable, he spends his free time writing books on cuisine and language.

After composing for Brigitte Bardot (*Fille de paille*, with F. Gérald), Gérard Lenorman [3] replaced Julien Clerc in the musical *Hair* (1970). With this, he had launched his career. The *"Petit Prince"* of French song, Lenorman created some of the public's favorite numbers, including *La Ballade des gens heureux* (with Delanoë, 1976).

④

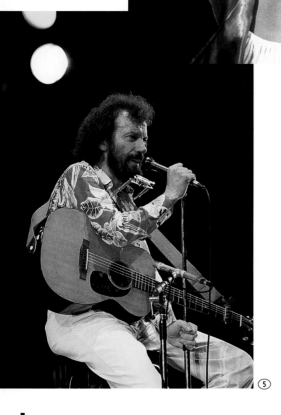

⑤

In 1966 Antoine [5] had everything needed to shock the French—long hair, flowered shirt, little voice, feeble melodies. He became a phenomenon with his *Élucubrations* and his famous *"Oh Yé!"* Within a few years, he had changed course and achieved his dream—sailing around the world. He also quickly learned to profit from the voyages by turning them into songs, books of photographs, and video cassettes.

In May 1968, equipped with a new text by Étienne Roda-Gil, a sure sense of melody, and a unique voice, Julien Clerc became one of the best things in French song [4]. From albums to shows, Clerc confirmed his importance, and he remains, after thirty years in the business, a singer favored by the young

On a 33 rpm, Claude Nougaro [6] revealed his tenor voice, swing beat, and inimitable phrasing. Well educated, he dared to refer and to relate; curious, he flirts with South American music or even looks to Africa for inspiration. In New York he recorded an album *(Nougayork)*, which would seduce a whole new generation then unaware of him. Energized by this fresh lease on life, Nougaro finally discovered his place among the unavoidable masters of French song.

⑥

La

Bohème

A

fter love and friendship, nostalgia, it seems to me, is the material most often used to construct a beautiful song. And why not? The material is as solid as time—fixed for eternity—in a form that depends upon the person using it. The same event, according to how it was experienced, may be evoked in all manner of ways, historical, journalistic, poetic, comedic, sad, gay, regrettable, or positive. Memory, after all, is rich in whatever it may contain, depending on whether it has been well or poorly nourished.

Nostalgia is generally defined as regret. For me, however, it is the pleasure of reliving moments of life, or life itself, by illuminating them with an aureole of beauty, merriment, or, sometimes, melancholy.

The song is almost always triste. Recently, however, a radio station chose to identify itself with the word "nostalgia," certainly not for the purpose of making the public sad. I, for one, love hearing an old song, even one linked to circumstances less than agreeable. For example, Charles Trenet's *Verlaine*, premiered in the midst of war, or *Mademoiselle Swing* reminds me not of the period's horror but, on the contrary, of a ray of sunlight in a world of gloom. Nostalgia is not always synonymous with melancholy.

Admittedly, I'm approaching finale, with the result that a nostalgic song can stir mixed feelings, ranging from pleasure to turmoil by way of regret. This last category figures among the most frequently explored, in other cultures as well as

Cora Vaucaire (here [1] in 1964) came to song by way of the theatre, which explains her ability to bring texts so vividly to life. Always committed to poets, she has ventured into popular song as well as into movie music: *La Complainte de la butte* (Jean Renoir/Georges Van Parys) for *French-Cancan* and *Trois petites notes de musique* (Henri Colpi/Georges Delerue) for *Une aussi longue absence*. In the 1940s, when still a young aspirant, Vaucaire sang Francis Carco's *Chanson Tendre* in a Left Bank cabaret. "I've made no mistake," said Édith Piaf, who once again had discovered a talent. All her life, Piaf (here [2] in 1958) undertook to encourage, stimulate, and advise. Her greatest success was Yves Montand [3], to whom she offered every opportunity to grow and make his mark. True, the soil was fertile; moreover, the results exceeded even the highest of the Pygmalion's hopes.

Lyrics : Jacques Plante ▪ **Music** : Charles Aznavour, 1966

Excerpt from the operetta *Monsieur Carnaval*

Je vous parle d'un temps
Que les moins de vingt ans
Ne peuvent pas connaître
Montmartre en ce temps-là
Accrochait ses lilas
Jusque sous nos fenêtres
Et si l'humble garni
Qui nous servait de nid
Ne payait pas de mine
C'est là qu'on s'est connu
Moi qui criais famine
Et toi qui posait nue
La bohème La bohème
Ça voulait dire qu'on est heureux
La bohème La bohème
Nous ne mangions qu'un jour sur deux
Dans les cafés voisins
Nous étions quelques-uns
Qui attendions la gloire
Et bien que miséreux
Avec le ventre creux
Nous ne cessions d'y croire
Et quand quelque bistrot
Contre un bon repas chaud
Nous prenait une toile
Nous récitions des vers
Groupés autour du poéle
En oubliant l'hiver
La bohème La bohème
Ça voulait dire tu es jolie
La bohème La bohème
Et nous avions tous du génie
Souvent il m'arrivait
Devant mon chevalet
De passer des nuits blanches
Retouchant le dessin
De la ligne d'un sein
Du galbe d'une hanche
Et ce n'est qu'au matin
Qu'on s'asseyait enfin
Devant un café crème
Epuisés mais ravis
Fallait-il que l'on s'aime
Et qu'on aime la vie
La bohème La bohème

Ça voulait dire on a vingt ans
La bohème La bohème
Et nous vivions de l'air du temps
Quand au hasard des jours
Je m'en vais faire un tour
À mon ancienne adresse
Je ne reconnais plus
Ni les murs, ni les rues
Qui ont vu ma jeunesse
En haut d'un escalier
Je cherche l'atelier
Dont plus rien ne subsiste
Dans son nouveau décor
Montmartre semble triste
Et les lilas sont morts
La bohème La bohème
On était jeune on était fou
La bohème La bohème
Ça ne veut plus rien dire du tout

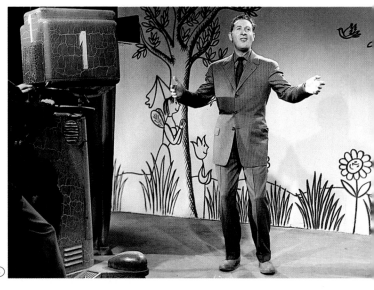

④

The repertoire of Charles Trenet (here [4] in 1951) is built on nostalgia. The stenches of an awful childhood provide the stout underpinnings of a mature oeuvre full of joy and insouciance. The "singing fool," the swinging troubadour, the eternal Catalan kid found his inspiration in the smells, anxieties, discoveries, and experiences of an earlier life. For Trenet, nothing was more important than, as Jacques Brel sang, being "old without beng adult."

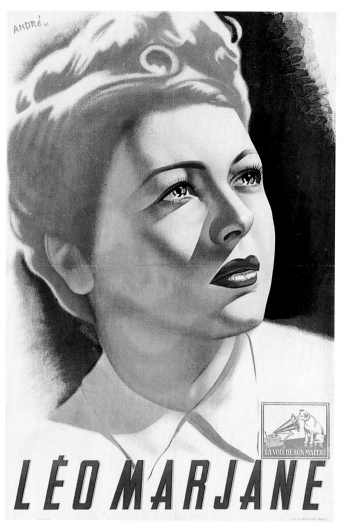

LÉO MARJANE

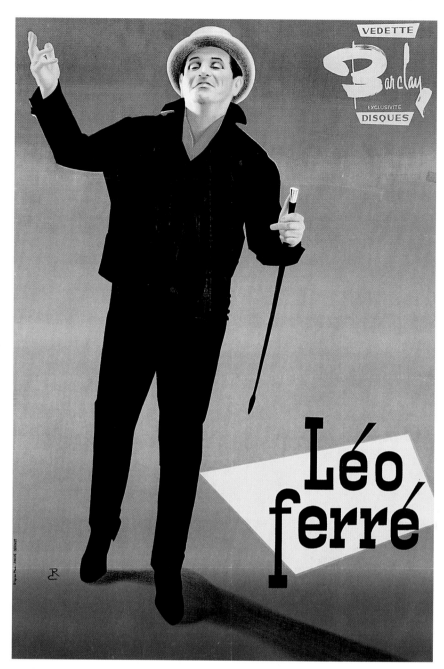

Léo ferré

JEAN SABLON

RINA KETTY
GRAND PRIX DU DISQUE

DISQUES Pathé

84 ▲

The public loves sad or melancholy songs. Ruptures, failed amours, times that pass and efface "the steps of divided couples." Léo Marjane introduced *Begin the Beguine* to France and then departed for the United States, leaving fans to talk about the "melodious immobility" of that great female crooner. During the war she was an immense star (*Je suis seule ce soir*), but made the mistake of singing on Radio Paris, the collaborationist station, as well as for the Occupation forces. "I'm myopic," she later explained to the Purification Committee. If there is a French crooner, it is certainly Jean Sablon, with his warm voice and his youthful physique. He took up with jazz musicians, introduced the songs of Trenet, conquered America, and returned to France singing the songs of and with Mireille. The "Bing Crosby of France," Sablon was a hit at the ABC in 1939 when he performed *Le Pont d'Avignon* in a jazz arrangement, *Je tire ma révérence* (P. Bastia), and, above all, *J'attendrai* (L. Poterat/D. Olivieri). Rina Ketty, born in Turin, came into her own in 1938 with *Sombreros et Mantilles.* In the 1950s, Gloria Lasso and then Dalida would also take up residence in the space Ketty helped open, that of chanteuse with an accent and a Latin temperament placed in the service of sentimental/exotic refrains. For the public to identify with sad songs, these should be kept simple. Léo Ferré, beginning in 1946, set about trying to capture the masses, but it would be years before he succeeded.

in France, whether articulated as the Brazilians' *saudad* or as the Anglo-Saxons' blues. Among the French, the song that best incarnates our sense of nostalgia is probably *Les Feuilles mortes*, which seems all the more tender for having sprung from a vibrant passion.

"*Où sont-ils à présent / À présent mes 20 ans?*" sings the nostalgic Aznavour in *Hier encore*, which all but leads into that gem *La Bohème*: "*Ça voulait dire qu'on est heureux.*" The height of sadness is attained in Françoise Dorin's *Que c'est triste Venise*, which concludes: "*Quand on ne s'aime plus.*" *C'était moi*, a pretty song by Vidalin sung by Bécaud, recalls "*Celui qu'on appelait le voyou de la plage.*" *La Dernière séance* by Eddy Mitchell evokes the closing of a cinema and the actors who stirred his youthful imagination. The most nostalgic of my songs is undoubtedly *Soirées de Prince*, a number beautifully sung by my departed friend Jean-Claude Pascal: "*J'ai donné des soirées à étonner les princes, dans cette chambre usée par trois siècles d'amour / Et de ma vieille chambre il ne reste plus rien.*" An old song of the Belle Époque put it this way: "*Lorsque tout est fini, quand se meurt notre beau rêve pourquoi pleurer les jours enfuis / Pourtant le coeur n'est pas gueri, quand tout est fini.*"

"*La nostalgie n'est plus ce qu'elle était,*" wrote Simone Signoret. I don't share this opinion. The world is always changing its shape but never its soul, and its soul is us: human beings—always in love, resentful, gay, sad, and nostalgic—we who forget pain and ugliness to remember "the sunny side of the street."

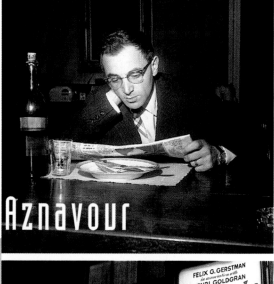

la bohème à la Aznavour

The Slavic soul of Charles Aznavour blends love with nostalgia, in lyrics, music, and voice that have become vehicles for this kind of *tristesse,* a condition which satisfies even as it wounds. The feeling may be blue, but the situations are never melodramatic, and while the hero may suffer, his despair always seems curable. The poetic realism of Aznavour springs from his own disappointments in love. This was a territory once claimed by women. Aznavour was the first man who dared to expose his heartache, the first to exploit his feelings, failures, and tears. A clever man, he understands that the audience for love music is dominated by women. To seduce them, Aznavour cultivated authenticity, playing on the strings which bind sensitive men and women. He has charmed the planet, beaten all records for longevity, not to mention notoriety, and succeeded in every culture. Further, he grows more popular every year, among all generations. A child of the people, Aznavour appears to have been genetically coded for performing. By dent of work and will, he has mastered his art, a popular art which wins by engaging the heart and the senses.

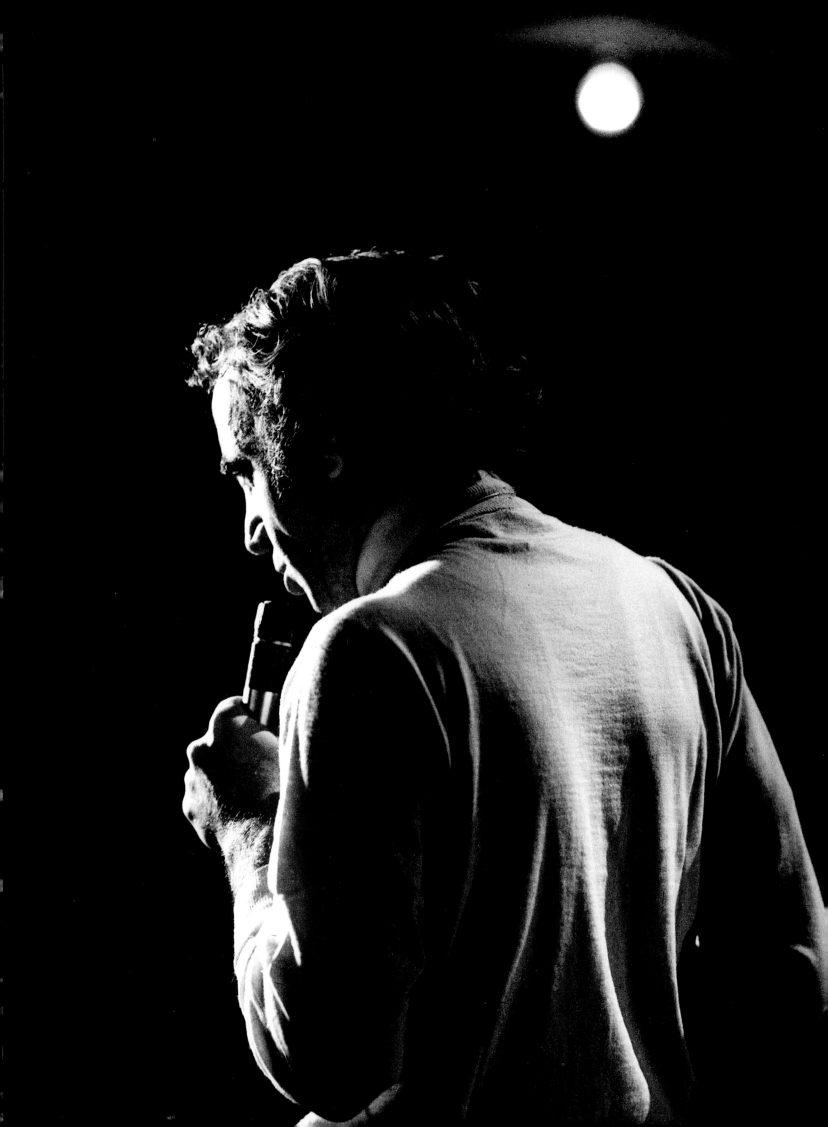

la vie en rose

The lights go out, save for a spot, leaving the artist lone in his circle of luminosity. Behind him it's dark; in front of him, more darkness, filled with an attentive audience. The voice unfolds, wraps about grave words, along with gestures driven by powerful emotion. Song and theatre are one. For Mouloudji [2], film, stage, song, and, later, writing and painting are all vehicles for translating emotions, for dispelling a voracious malaise. Trained as a coiffeur, Serge Reggiani [3] became an actor by accident. Then, already beyond forty, he conceived a veritable passion for singing, which, beginning in 1969, he reinforced with his experience as an actor. Reggiani selects talents who write to his exact measure, ranging from melodramatic despair and *Le Petit garçon* through *Le Barbier de Belleville* by Lemesle and Alice Dona to torrid declarations of love such as *Sarah*. Juliette Gréco [1] offers writers a style that places sensuality in the service of her sense of the world. Gréco is female without apology, at once both vamp and soldier in the cause of humanity, a living witness to an important moment in contemporary history. This was the Liberation, which left those who lived through it convinced deep in their hearts that Man merits no more than vigilant confidence.

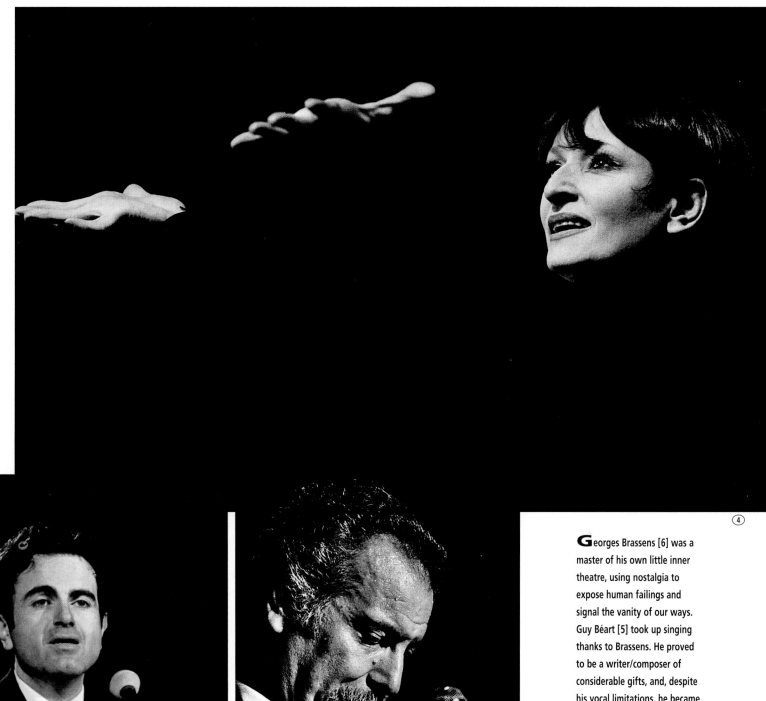

Georges Brassens [6] was a master of his own little inner theatre, using nostalgia to expose human failings and signal the vanity of our ways. Guy Béart [5] took up singing thanks to Brassens. He proved to be a writer/composer of considerable gifts, and, despite his vocal limitations, he became, in a single album, a true pillar of song. As for Barbara, voice, phrasing, gesture, world—everything is original [4]. The audience is happy to be caught in a trap where beauty and a fear of speaking too frankly cohabit with the extravagance and excess of a bird of prey.

la vie en rose

To touch and move, nostalgia must be clothed in sepia, and melodies caressed by an instrument's softness. Michel Legrand [1], the complete musician, together with Jacques Damy, invented the *film chanté (Les Parapluies de Cherbourg, Les Demoiselles de Rochefort)*. In Hollywood Legrand won three Oscars (*The Thomas Crown Affair, The Summer of 42,* and *Yentl*), and the best artists in the business have interpreted his songs. With the writers Eddy Marnay and Jean Dréjac, Legrand created a gentle, satiric world in which he used the human voice like an instrument.

Since his first record in 1950, the French have been completely enamored of Félix Leclerc, a deep-voiced bard and the first Québécois to sing of national identity in France. Unknown in Canada, Leclerc owed his beginnings to Jacques Canetti, the scout, organizer, and general music man for variety. Within months, Leclerc found himself among the stars (here [2] at the Trois Baudets together with Philippe Clay, Pierre-Jean Vaillard, and Fernand Raynaud). It was also Canetti who invited Jacques Brel [3] to Paris. It took time for the public to embrace the young Belgian, who seemed

wise beyond his years. Brel took off with the record *Quand on n'a que l'amour.*

The popular and demanding Gilbert Bécaud [4] can incarnate *Les Marchés de Provence* as well as the grief of a forsaken lover (*Et Maintenant*). Jean-Jacques Debout (here [5] in 1966) made himself known by recording a Maurice Vidalin and Jacques Datin melodrama, *Les Boutons dorés.* Johnny Hallyday (*Pour moi la vie va commencer*), Sylvie Vartan (*Comme un garçon*), and many others would turn his compositions into hits, while Debout continued to pursue a career as a tender-voiced singer.

①

②

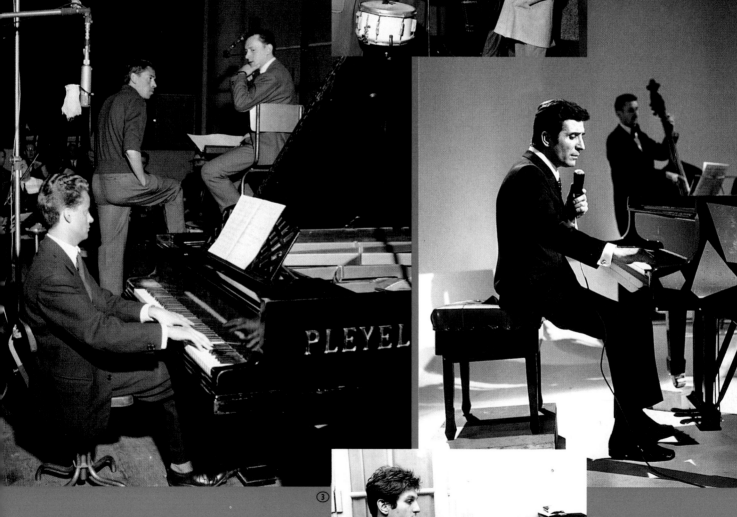

③

④

⑤

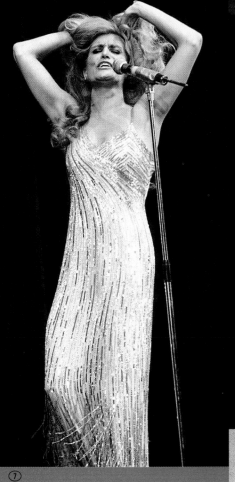

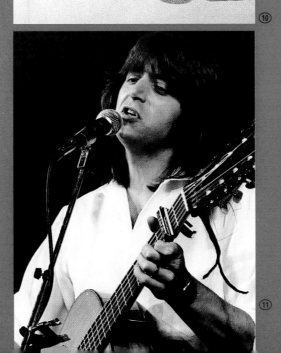

Arriving from Egypt to become an actress, Dalida [7] found herself in the role of chanteuse. Benefiting from the public's infatuation with sunny voices, not to mention the power of her husband, Lucien Morisse, director of Europe No. 1, Dalida became a millionaire recording star, one of the first women to do so in France. A dazzling interpreter, she could handle both emotion and extravagance. In her three-decade career, Dalida explored every style, even at the risk of becoming a slave to fashion. One of the last divas of popular art, she ended her run by playing in *Le Sixième Jour,* a film by Youssef Chahine. Dalida took her own life on 2 May 1987.

An encounter with Ferré proved decisive for Catherine Sauvage (here [6] in 1965). In 1954 she won the Grand Prix with a record of *L'Homme.* Six years later she gave a recital at the Gaité-Montparnasse, offering a mixed program which included songs by Ferré, Brassens, Aragon, Vigneault, Mac Orlan, Brecht, etc. In the 1960s Léo Ferré (here [8] in 1962) emerged as a popular artist with *Jolie Môme* and poems by Jean-Roger Caussimon: *Comme à Ostende* and *Monsieur William.* The 1970s would be important years for Ferré, who then wrote *C'est extra* and *Avec le temps.* Jean Ferrat (here [9] in 1964) caught the public's attention with *Ma*

môme, then with *Deux enfants au soleil,* and again with *La Montagne,* a realist though poetic portrait of the rural world in mutation. *La Montagne* remains one of his most demanded songs. The family of nostalgic poets includes Salvatore Adamo [10] and Yves Duteil [11]. The first managed to put his melancholy refrains across even at the height of the twist craze, thereby reconciling ancients and moderns. Duteil launched his career in the 1970s with a neo-folkloric repertoire. A real hit was *La Langue de chez nous.* In the 1980s *Prendre un enfant par la main* was generally thought to be the song of the decade.

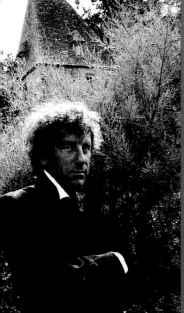

①

③

After yé-yé came a rich and important period. Reacting against textual poverty, a whole generation of artists fell in behind Serge Gainsbourg [4], who, once more in full favor, cast his cynical eye on the excesses of an ephemeral trend. Michel Polnareff [2], the most Anglo-Saxon of France's writer/composers, played with his soaring voice, as well as with his sense of melody, to produce numbers of great originality. Jane Birkin [3] has always been considered the tender, distaff side of Serge Gainsbourg. To her he dedicated *Fuir le bonheur de peur qu'il ne se sauve, Les Dessous chics, Amour des feintes,* and others. Poetry would discover new paths closer to the new sensibility. Beginning in 1974, Alain Souchon [1] fashioned songs in baby talk: *T'are ta gueule à la récré, Allô maman bobo.* He retraced steps through childhood (*Bidon, Jamais content*), looking upon the world of adults with derision (*Poulailler's Song, Le Bagad de Lann Bihoué*).

②

④

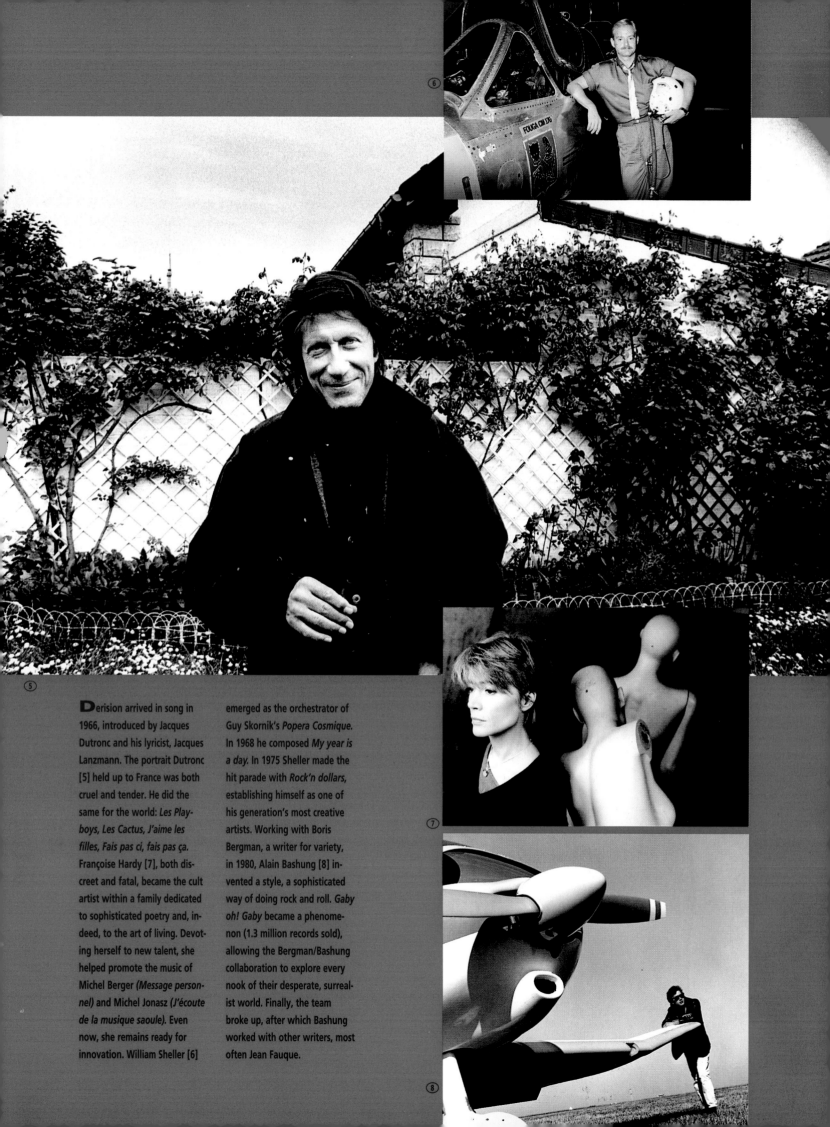

Derision arrived in song in 1966, introduced by Jacques Dutronc and his lyricist, Jacques Lanzmann. The portrait Dutronc [5] held up to France was both cruel and tender. He did the same for the world: *Les Playboys, Les Cactus, J'aime les filles, Fais pas ci, fais pas ça*. Françoise Hardy [7], both discreet and fatal, became the cult artist within a family dedicated to sophisticated poetry and, indeed, to the art of living. Devoting herself to new talent, she helped promote the music of Michel Berger *(Message personnel)* and Michel Jonasz *(J'écoute de la musique saoule)*. Even now, she remains ready for innovation. William Sheller [6] emerged as the orchestrator of Guy Skornik's *Popera Cosmique*. In 1968 he composed *My year is a day*. In 1975 Sheller made the hit parade with *Rock'n dollars*, establishing himself as one of his generation's most creative artists. Working with Boris Bergman, a writer for variety, in 1980, Alain Bashung [8] invented a style, a sophisticated way of doing rock and roll. *Gaby oh! Gaby* became a phenomenon (1.3 million records sold), allowing the Bergman/Bashung collaboration to explore every nook of their desperate, surrealist world. Finally, the team broke up, after which Bashung worked with other writers, most often Jean Fauque.

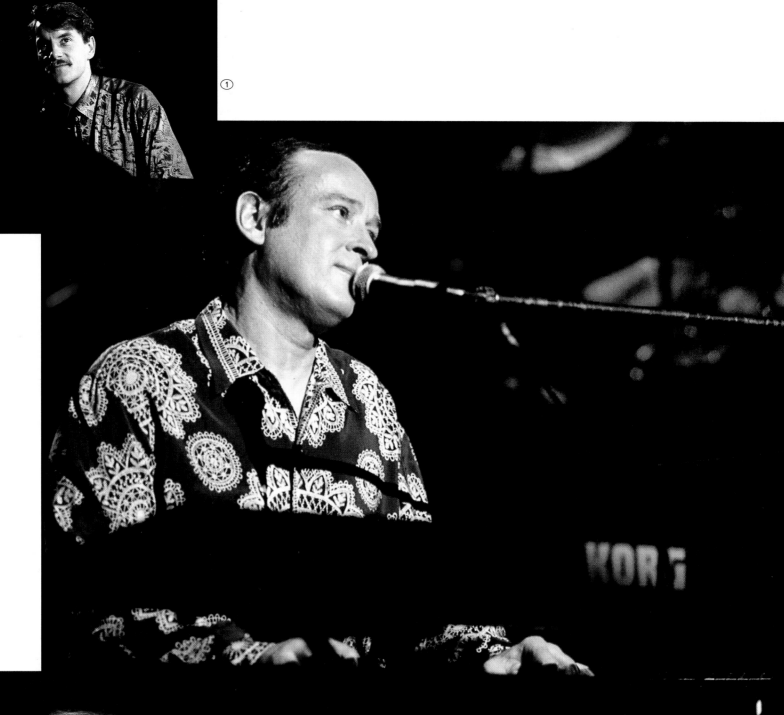

①

②

③

It takes a good fifteen years to "fabricate" a *monstre sacré*. The professional journey must follow that of a generation that identifies with the artist and matures in step with his or her songs. In the mid-1970s radios carried a strange voice alive with Gypsy vibrato and bluesy heat. This was the voice of Michel Jonasz (here [2] at Montreal's Francofolies in 1993), whose performances were events. The more his reputation grew, the more Jonasz remained discreet, refusing even to give interviews. In 1988 he produced a show, *La Fabuleuse histoire de Mr. Swing*, without a song the public knew or a stroke of publicity. Francis Cabrel (here [1] in 1989) had just finished his second album when he decided to include *Je l'aime à mourir*, written in one hour. The song went to the top of every list. Recreated in Spanish and Italian, it sold altogether more than 2 million copies. This was in 1979, at the height of the disco mania, when Cabrel ballads had nothing in common with binary rhythms and synthesizer gimmicks. From the age of fourteen, Jean-Jacques Goldman [3] has made music. On 4 September 1981 he released an album which included *Il suffira d'un signe*, which became his springboard to fame. Hit followed hit until he came to be regarded as a kind of wizard capable of turning everything into triumph. Johnny Hallyday asked him for songs, as did Patricia Kaas, Céline Dion, Khaled, etc. Goldman (here in 1993), who wrote *Restos du Coeur*, does not rest on his laurels or play the big star.

The 1960s also yielded its harvest of stars. Thirty years later some of them are still there, crystallizing the nostalgia of their generation. French rock has given us two of our most remarkable troopers, both graduates of the Golf Drouot in its salad days. At the head of the class came Johnny Hallyday (here [7] in 1988), followed closely by Eddy Mitchell [4]. Beginning as vocalist for the Chaussettes Noires, Mitchell scored several hits on the variety stage, among them *Dactylo Rock, Tu parles trop*, and *Daniela*. This phase lasted from 1961 to 1963, the year his first album was released. After a brief slump in the late 1960s, he rebounded in the following decade and has continued to enjoy steady success (here at Bercy in 1994). In 1962, when twist and rock were eclipsing every other musical form, a young baritone from Toulouse managed to combine his two passions—poetry and jazz—on a 25 cm concocted with Michel Legrand: *Le Cinéma*. Then with Jacques Datin he did *Une petite fille, Cécile ma fille*, and *Le Jazz et le java*. Claude Nougaro (here [6] in 1987) became the darling of the public. Julien Clerc [5], beginning in 1968, played on sentimental nostalgia. He even turned variety upside down with texts by Étienne Roda-Gil and Maurice Vallet first, and then Jean-Loup Dabadie *(Femmes je vous aime)*, David MacNeil *(Melissa)*, and Luc Plamondon *(La Fille aux bas nylon)*. Julien Clerc (here in 1994), with his impressive repertoire of hits, has endeared himself to all generations.

③

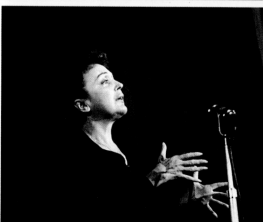

④

La môme Piaf, later Édith Piaf [1, 3, 4], brought nobility to the realist song—the mélo. Her innate sense of selection, plus a unique voice and extraordinary interpretive gifts, allowed Piaf to blend the popular with the legendary. Charles Dumont [4] is best known as the composer of more than thirty songs for Piaf, among them Non, je ne regrette rien. The emblematic song of the mélo genre is Les Rose blanches, interpreted by Berthe Sylva. A tremendous hit, White Roses sold 3 million in sheet-music form [2].

The *mélo* song is the one that brings tears to the eyes. In the eighteenth century melodrama was a musical genre requiring an orchestra to underline the events or dramatic sentiments expressed by the actors. This kind of melodrama has now become *mélo,* and those who practice it haven't the least fear about using sorrow as a means to move the audience. The genre, once very much in vogue, has now fallen out of favor. Notwithstanding, several years ago Gérard Berliner hit it big with *Louise,* the distress of whose heroine left no soft heart untouched. Michel Polnareff, in *Le Bal des Laze* ("I'll hang tomorrow at dawn"), also revitalized the form, with a bit of help from me. And so did Bécaud with *Marie Marie,* a number adopted by Montand and Marlene Dietrich, who thus told the story of poor prisoner number 14,200 forsaken by Marie.

Still, the great *chansons mélo* date from the first half of the twentieth century, and for an obvious reason: The horrors of war have long since surpassed even the darkest fictions, and few writers have had the courage of Jean Ferrat in *Nuit et brouillard* to address subjects likely to prove too weighty for the slender structures of popular song.

One pair of collaborating authors have left their mark on the *complainte,* as

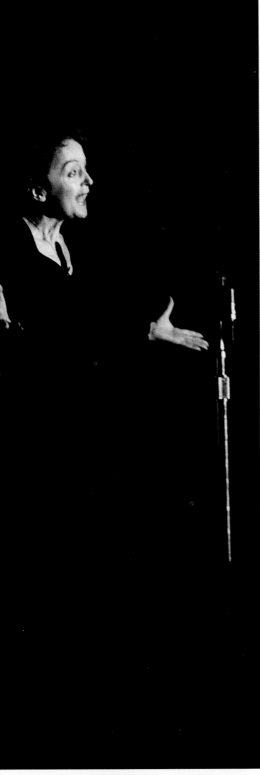

the dramatic song is sometimes called. F. Bénesch and E. Dumont are particularly known for *La Femme aux bijoux, Du gris,* and *Tu voudrais me voir pleurer.* For me, however, *Les Roses blanches* represents mélo at its best. This tale, first told by Berthe Sylva in the second half of the 1920s, involves a child who, knowing his mother's taste for white roses, is preparing to take her a bouquet in the hospital. At the story's exquisite climax the authors have the mother die before her child can arrive bearing the white roses, all of which is accompanied by mounting sobs in the audience. Michèle Torr, a beautiful chanteuse of our own time, added *Les Roses blanches* to her repertoire, again to great emotional effect.

Les Goélands sung by Damia ("The sailors who perish at sea"); *La Légende des flots bleus,* which made me weep whenever my mother sang it; *L'Hirondelle du faubourg ("Une pôve fille d'amour née un jour de la saison printanière, d'une petite ouvrière")*—such songs verge on masterpieces even if times and tastes make them seem a bit over the top. Édith Piaf was probably the last *tragidienne* in an era when wretched narratives were still recited. *Mon Légionnaire* and *L'Accordéoniste* are unquestionably great mélos. It's not the public that rejects the genre; it's the style of today's popular song.

In 1936, in *Pépé le Moko,* a Julien Duvivier film, Fréhel [6] sang *Où est-il donc?,* a song by Lucien Carol and Vincent Scotto, premiered in 1925 by Georgel. Damia [7] has been called the *tragédienne de la chanson.* One of the realists, she exploited a varied repertoire ranging from melodrama (*La Suppliante, La Malédiction, Sombre dimanche*) through popular *complainte* (*La Chaîne*) to poems with musical settings (*Le Ciel est par-dessus le toit* by Verlaine and Reynaldo Hahn).

⑥

⑦

⑤

Le Chant

des

partísans

At first glance, song and history would not appear to be natural bedfellows. But nothing could be further from the truth. A primary function of song consists in bearing witness to key events in ongoing human history.

Jean Ferrat's *Nuit et brouillard* has much to say about the horror of the death trains, just as *Potemkine* tells of the mutinies in the Black Sea on the eve of the Russian Revolution. *Dansons la Carmagnole* is almost reportage on the revolutionary tumult at the end of Louis XVI's reign. *La Marseillaise* is a rousing patriotic appeal to stir the public's conscience: *"Qu'un sang impur abreuve nos sillons." "Le Régiment de Sambre et Meuse marchait toujours au cri de liberté"* and *"La République nous appelle, sachons vaincre ou sachons mourir"*— all impel soldiers to take up arms. *L'Internationale*, a poem written by Pottier at the end of the nineteenth century, has become the Marxist anthem. *Le Chant des partisans* by Kessel, Druon, and Marly: *"Ohé partisans, ouvriers et paysans, c'est l'alarme / Ce soir l'ennemi connaîtra le prix du sang et des larmes."* Such lyrics helped sustain the spirit of resistance against the German Occupation. *Bella Ciao*, a song taken up by Yves Montand, once galvanized the followers of Garibaldi during the Risorgimento, the struggle that produced a unified Italy in the middle of the nineteenth century.

Historical witness may also take a lighter turn, as in *Elle s'était fait couper les cheveux*, a song from the hair-bobbing 1920s, or in *Il était swing, zazou zazou* by Johnny Hess, a work of the 1940s. In 1955

Soldiers may leave for war with flowers stuck in their gun barrels, but it's to song that they march into battle. Because of songs, moreover, they remember those who await them at home. Every period of conflict has produced its memorable refrains. During World War I, Lucien Boyer, paymaster for the 19th train squadron, was put in charge of disseminating propaganda throughout the war zone. A fertile talent, he wrote almost 2,000 songs, several of which became popular hits: *La Chanson des poilus*, *Les Goélands* (immortalized by Damia), *Tu verras Montmartre*, *Ça c'est Paris* (for Mistinguett), *Ah! qu'il est beau mon village*, etc. By mistake, he received the Légion d'honneur, Georges Clémenceau having been convinced he was decorating the author of *Quand Madelon* rather than the person responsible for *La Madelon de la victoire*. While some songs contribute to troop morale, others attempt the opposite and succeed, despite censorship. Georges Brassens, in an early work, was at his best in an anti-militarist couplet: *". . . la musique qui marche au pas, cela ne me regarde pas"*

Léo Ferré, sworn enemy of all institutions and powers, went so far as to attack his backer, Eddie Barclay, in a song denouncing concessions made for the sake of publicity and celebrity. *Mr. Barclay m'a dit* cast Ferré as a fully aware and consenting victim, wherein lies the song's edge—its paradox.

Lyrics : Maurice Druon and Joseph Kessel ▪ **Music** : Anna Marly, 1944

Ami, entends-tu
Le vol noir des corbeaux sur nos plaines.
Ami, entends-tu
Ces cris sourds du pays qu'on enchaine
Ohé partisans, ouvriers et paysans,
C'est l'alarme.
Ce soir l'ennemi connaîtra le prix du sang
Et des larmes.
Montez de la mine ;
Descendez des collines,
Camarades,
Sortez de la paille
Les fusils, la mitraille,
Les grenades.
Ohé les tueurs,
À la balle et au couteau,
Tuez vite,

Ohé saboteur
Attention à ton fardeau
Dynamite...
C'est nous qui brisons
Les barreaux des prisons,
Pour nos frères,
La haine à nos trousses
Et la faim qui nous pousse,
La misère.
Il y a des pays
Où les gens au creux des lits,
Font des rêves.
Ici, nous vois-tu,
Nous on marche et nous on tue...
Nous on crève...
Ici chacun sait
Ce qu'il veut, ce qu'il fait

Quand il passe,
Ami, si tu tombes,
Un ami sort de l'ombre
À ta place,
Demain du sang noir
Sèchera au grand soleil
Sur les routes,
Chantez compagnons,
Dans la nuit la liberté
Nous écoute...
Ami entends-tu,
Les cris sourds du pays qu'on enchaîne !...
Ami entends-tu,
Le vol noir des corbeaux sur nos plaines !...
Oh oh oh oh oh oh oh oh oh oh oh...

From the end of World War II, Yves Montand [1, 2, 3] sang Jacques Prévert. This was a new direction taken by a man who had become known for his way with refrains based on cowboy and love songs. In 1953 Montand embraced Francis Lemarque's *Quand un soldat*, a song ignored by established programmers. It ended in these words: *"Quand un soldat s'en va-t-en guerre il a / Des tas d'chansons et des fleurs sous ses pas. Quand un soldat revient de guerre il a / Simplement eu d'la veine et puis voilà."* In 1968 Montand expanded his repertoire to include texts by Nazim Hikmet; further, he took public stands which would never cease to evolve and solidify.

Juliette Gréco [4], from her first appearance, has always presented the image of an engaged woman. The child of suffering and humiliation, she emerged from the war years bruised and angry. She brought to song a new feminine face, remote from that of the traditional chanteuse who could convey her sense of things only through a recitation of quotidian travails. Gréco relegated the submissive woman to the realm of the antique. She speaks up, uses her beauty to articulate truths, and fears no one.

In 1954 Mouloudji (here [5] in 1975) sang Boris Vian's *Le Dé-serteur* the day the fortress at Dien-Bien-Phu fell. The performance was a disaster for his career. Not only did the song garner boos; it prompted Paul Faber, a city councilor for Paris, to propose that the author and his interpreters be censured for their "insult to veterans." In 1966 Peter, Paul, and Mary offered a bilingual version at the height of the Vietnam War. Serge Reggiani [6] then sang a restored version, using Vian's original words: *"Monsieur le Président,"* in place of *"Messieurs qu'on nomme grands."* As for the deserter theme, Brassens [7] returned to it several times. In 1972 he introduced eleven new *chansons*, among them *Mourir pour des idées*. The refrain asserts: *"Mourons pour des idées, d'accord, mais de mort lente."* The song then concludes with a reference to Vian's text: *"Ô vous, les boutefeux, ô vous les bons apôtres / Mourez donc les premiers, nous vous cédons le pas. Mais de grâce, morbleu! laissez vivre les autres! La vie est à peu près leur seul luxe ici-bas."* Brassens, an avowed anarchist, preferred "to cross at street corners rather than risk having to deal with the police."

Boris Vian sent up snobs in *J'suis snob: "J'veux qu'on m'enterre dans un suaire de chez Dior."* I almost forgot, unpardonably, *Le Temps des cerises*, long considered the hymn of the 1871 Commune.

It is important to distinguish between the historical song, concerned primarily with stating the facts, and the engaged song, a vehicle for political, religious, or philosophical ideas. The engaged song took an aggressive turn during the 1950s in both France and the United States. Boris Vian dealt with conscientious objectors in *Le Déserteur: "J'ai reçu mes papiers pour aller à la guerre / Je ne veux pas la faire / Je ne suis pas sur terre / Pour tuer les pauvres gens."* Bécaud and I wrote a song that shocked the Leftist media by its commitment to De Gaulle: *Tu le regretteras*. History has proved us right. With Michel Sardou, we've even had songs about the secular/religious school argument or the luxury liner *France*, turned over to foreigners. Then there's *Vladimir Illitch*, a verbal trial acknowledging the decadence of Communism. Charles Aznavour has sung Armenia magnificently, the land of his cruelly martyred ancestors. In *Je suis pour* Michel Sardou has deplored the relative indifference to law since the elimination of capital punishment. As for *Le Temps des colonies*, a perfectly innocuous number, it was initially accused by the humorless of being "colonialist." Nougaro and I have commented about *les événements* of May 1968. Today the satirical song is in decline, for want of an outlet. This is a pity. Since the time of the medieval poet François Villon, the pamphlet has been a sign of social health.

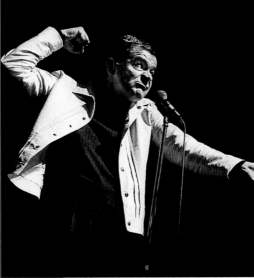

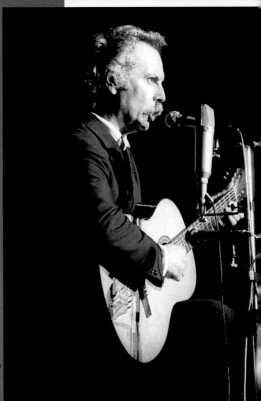

Ferrat

Traditionally, engaged singers identify with the Left. Even if they are not card-carrying members of a political party, the ideas in their songs establish them as active militants, at least for the critics and the public. Jean Ferrat has never hidden his convictions, even while refusing to join the Communist Party. He confines his engagement to song, preferring freedom over some imposed line of thought or action. A clear statement of his belief in power for the Left is *Le Bilan,* a song his enemies would love to see fade away. Ferrat, like all labeled artists, considers himself a victim of the ostracism he provokes. In 1972 France's public television station would not allow him to sing *Un air de liberté,* in which he attacked Jean d'Ormesson in particular. The incident became something of a national scandal, causing Ferrat to be blacklisted by Conservative institutions. While holding himself aloof from his own profession, Ferrat continues to play the vigilant observer, regularly issuing albums composed of social commentary, among other things. Every time he flays the demagogic powers, he discovers a large audience still identified with *France,* a song in his repertoire since the 1960s.

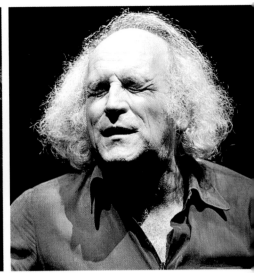

Ferré

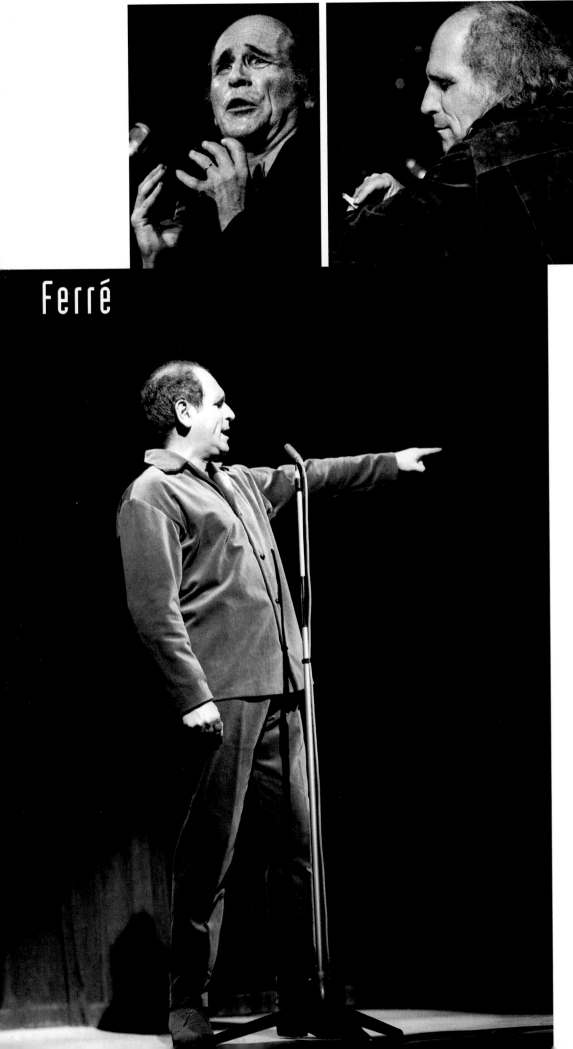

poetic engagement

The statements of Léo Ferré are more ambiguous, more poetic. An anarchist eager for the success of his songs, whatever the cost to himself, Ferré exploits anti-conformism with such talent and sincerity that inevitably he appears suspect in the eyes and ears of his detractors. He has written: "Anarchy is the political formulation of despair. . . . Christ, sin, sorrow, the rich, the poor . . . we live in captivity to idea-words. . . . The morality of anarchy is inconceivable except in refusal. . . ." Ferré disturbs, provokes, attacks. Always and wherever he finds an audience, but never armed as one might expect. Gradually in the course of his artistic journey, he has moved away from the song in the traditional mode and evolved towards texts rather like oratorios. As this would suggest, he weds classical music, which he conducted in 1975 at the Palais des Congrès, to poetic lyricism placed in the service of a quest for happiness.

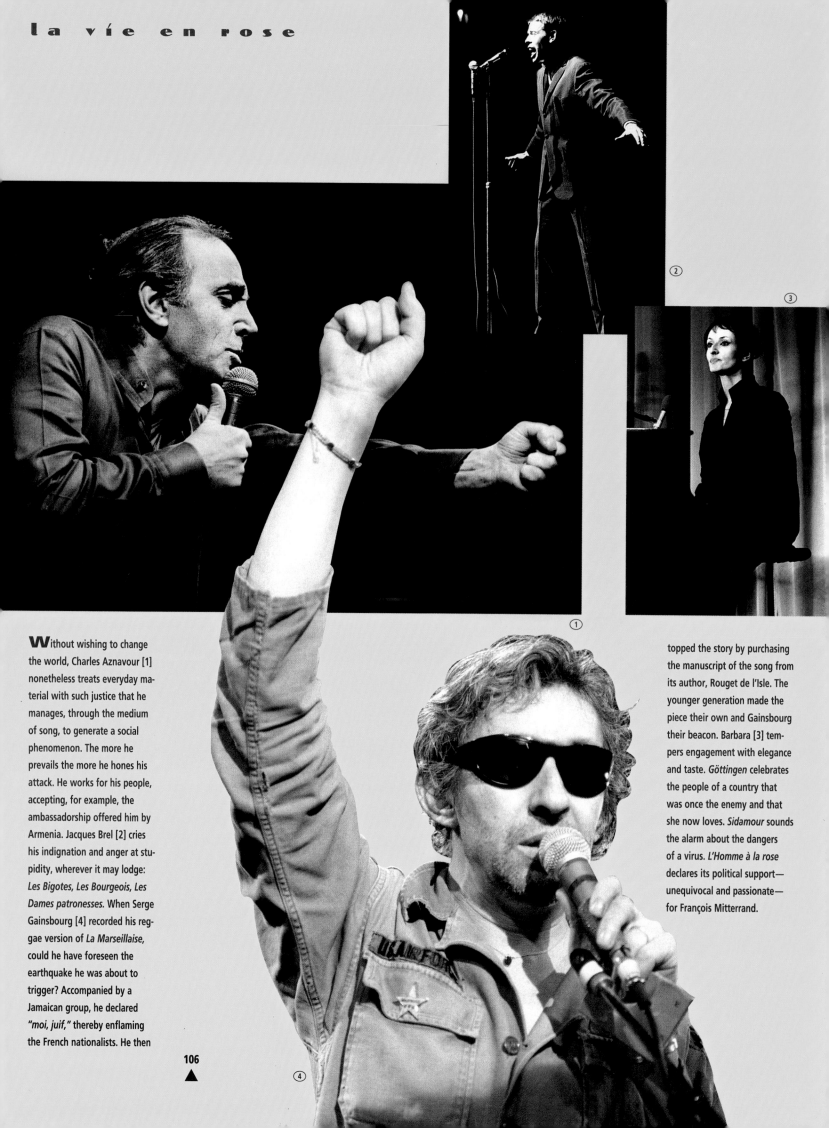

Without wishing to change the world, Charles Aznavour [1] nonetheless treats everyday material with such justice that he manages, through the medium of song, to generate a social phenomenon. The more he prevails the more he hones his attack. He works for his people, accepting, for example, the ambassadorship offered him by Armenia. Jacques Brel [2] cries his indignation and anger at stupidity, wherever it may lodge: *Les Bigotes, Les Bourgeois, Les Dames patronesses.* When Serge Gainsbourg [4] recorded his reggae version of *La Marseillaise,* could he have foreseen the earthquake he was about to trigger? Accompanied by a Jamaican group, he declared *"moi, juif,"* thereby enflaming the French nationalists. He then topped the story by purchasing the manuscript of the song from its author, Rouget de l'Isle. The younger generation made the piece their own and Gainsbourg their beacon. Barbara [3] tempers engagement with elegance and taste. *Göttingen* celebrates the people of a country that was once the enemy and that she now loves. *Sidamour* sounds the alarm about the dangers of a virus. *L'Homme à la rose* declares its political support— unequivocal and passionate— for François Mitterrand.

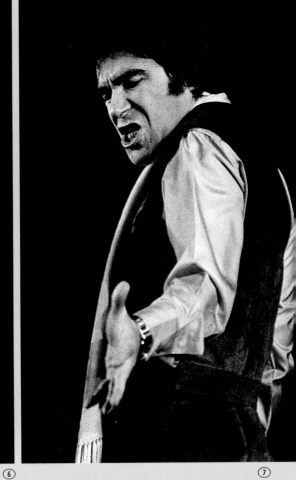

The authors whose words Gilbert Bécaud [5] sings have depicted the condition of a nation and its people. In 1960 Bécaud recorded *Tête de bois* (Delanoë), a portrait of two adolescents in revolt against established rules. In the 1970s he addressed the problem of isolation: *La Solitude, ça n'existe pas* (Delanoë), *Un peu d'amour et d'amitié* (Louis Amade), and in 1977 he won an Oscar for *Indifférence* (Maurice Vidalin). Algerian-born Enrico Macias [6] arrived in France in 1962 and became "le pied noir de la chanson." Initially he played on the theme of exile (*J'ai quitté mon pays*), but then expanded his repertoire to include assimilation (*Paris tu m'as pris dans tes bras* and *Les Gens du Nord* with words by Jacques Demarny). He won a major following in Algeria and even in Egypt, where, in 1979, he made a tour of "reconciliation" between Jews and Arabs. Claude Nougaro [7] did not present the image of an engaged artist, but couched within his words was a longing for justice and respect for humanity: "*Il serait temps que l'homme s'aime depuis qu'il sème son malheur. . . .*" Pierre Perret [8] exploits language—uses it as matter—to paint his inner theatre where powers and the desire for liberty, ignorance and generosity struggle for supremacy. From his refrains arises the infinite tenderness of humanity: *Ouvrez la cage aux oiseux, Lily,* or *La Petite Kurde.* Beginning in 1972, Brigitte Fontaine [9], in collaboration with Areski Belkacem, produced "anti-spectacles." With *Comme à la radio* of 1970 she established herself as one of the most dazzling exponents of the poetic song. "It's cold in the world," she sang in a number titled by the same phrase, which twenty years later, in an arrangement by Étienne Daho, remains a troubling presence. "Don't treat your desires as banalities," sings this disturbing artist in a disturbed world.

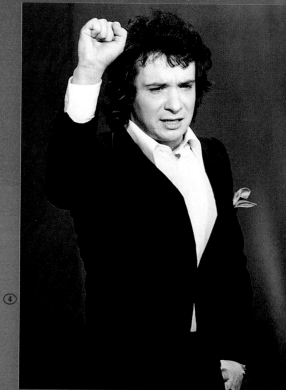

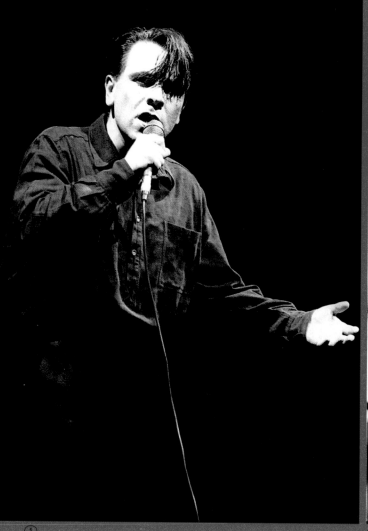

If there exists a singer with a true political conscience, it is Renaud [2], evident even in his first record: *Société tu ne m'auras pas* and *Hexagone*. He spares neither the media, the political class, his colleagues, nor institutions. He supported the re-election of François Mitterrand, for whose benefit he invented the famous phrase: *"Tonton, laisse pas béton!"* Since 1975 Renaud has built his oeuvre, a poetic commentary on our society, and done so in the face of blacklisting and defamation. Michel Sardou [4]—more to the Right, certainly, than to the Left—declares his opinions, keeps his engagements, and sings his vision, provoking a torrent of abuse from the Left. Sometimes his concerts became veritable riots; still, he sings, protected by the forces of order. Jean Guidoni [1] represents the hidden face of society, a vague, somewhat illicit world populated by shadows and anonymous souls in search of emotion. Since his appearance in 1980 at the Théâtre en Rond, with his powdered face and flaunted difference, Guidoni has immersed himself ever more deeply into his demons and his torments. An artist of pure engagement, he lays waste to every convention. Jacques Higelin's engagement is theatrical [3]. In the course of often endless monologues, he gives voice to his ideas, battles, passions, angers, and indignations. With Michel Fugain [5] confrontation takes a softer, more classical approach. His *Big Bazar* broke all sales records. *La fête*—fun, holidays, celebrations—constitutes the informing theme of his repertoire, which urges everyone to make the most of life (*Chante . . . Comme tu devais mourir demain*) and to rediscover essential values (*Fais comme l'oiseau*). In 1977 Fugain composed *Le Chiffon rouge*, which was adopted in 1980 by the population of Longwy during the steelworkers' strike.

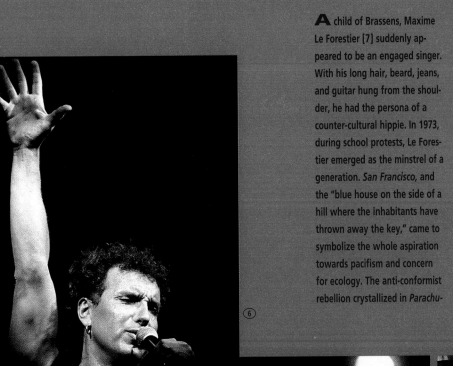

A child of Brassens, Maxime Le Forestier [7] suddenly appeared to be an engaged singer. With his long hair, beard, jeans, and guitar hung from the shoulder, he had the persona of a counter-cultural hippie. In 1973, during school protests, Le Forestier emerged as the minstrel of a generation. *San Francisco*, and the "blue house on the side of a hill where the inhabitants have thrown away the key," came to symbolize the whole aspiration towards pacifism and concern for ecology. The anti-conformist rebellion crystallized in *Parachu-tiste*, a pamphleteering song adopted by Joan Baez. Georges Moustaki [8] had stopped singing for several years when, in 1968, he decided to appear before a throng of striking workers. Open to every experience, he recorded, the following year, a song with which the public immediately identified him: *Le Métèque*. He also sang *Ma liberté, Le Droit à la paresse, Sacco et Vanzetti, Tout a été dit* (yet everything remains to be said), etc. Although given to confrontations and overtures, Moustaki is never militant, but he firmly defends his idea of life. Bernard Lavilliers [6] learned of the class struggle from his father, a proletarian and union leader. He lived through a rebellious childhood, tried boxing and theatre, but then took up singing. His song would be utilitarian, a song that denounced. Sparked by Ferré, Lavilliers cultivated a taste for absolute freedom (*N'appartiens à personne*). He oscillates between New York rock, salsa, and reggae, sharpening his words in order to lance the tumors of the planet.

⑥

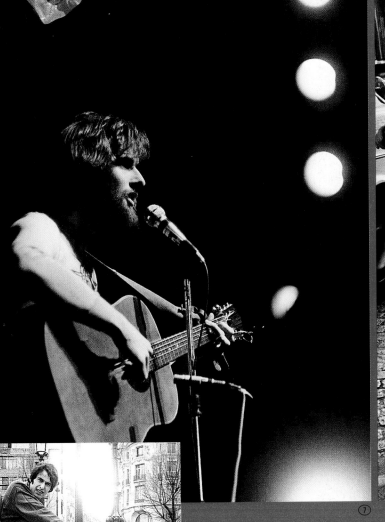

⑦

⑤

⑧

109
▲

la vie en rose

Front endpaper : Éditions Arpège
6 : Stills
7 : Roger Viollet - © P. Delanoë
8–9 : Archive Photos
10 : Coll. Christophe L
11 : Éditions Raoul Breton - Coll. Christophe L - Coll. Christophe L
12 : Archive Photos, Olympia 1962
13 : Coll. Jean-Loup Charmet - Archive Photos
14 : Coll. Jean-Loup Charmet - Coll. Jean-Loup Charmet - Carnegie Hall Archives
15 : Léonard de Selva/Tapabor - Léonard de Selva/Tapabor - Archive Association des amis d'Édith Piaf - Coll. André Bernard
16 : Archive Photos - Roger Parry/Ministère de la Culture, 1941 - R. Kasparian/J.L. Rancurel photothèque - Gian-Carlo Botti/Stills
17 : Léonard de Selva/Tapabor - Keystone - Archive Photos - Stills
18 : Jacques Aubert/Barclay - Studio Harcourt/Ministère de la Culture, 1948
19 : J.L. Rancurel photothèque - Goutline/Stills
20 : R. Kasparian/J.L. Rancurel photothèque - Archive Photos - Patrick Ullmann
21 : J.L. Rancurel photothèque - Archive Photos - Keystone
22 : Archive Photos - Archive Photos - Eric Bourret/Stills
23 : Archive Photos - J.L. Rancurel photothèque - Archive Photos - Archive Photos
24 : Archive Photos - Stills - Vu
25 : Christophe L - Archive Photos - Stills - Archive Photos
26 : Claude Schwartz/Vu - J.L. Rancurel photothèque - J.L. Rancurel photothèque - J.L. Rancurel photothèque - J.L. Rancurel photothèque
27 : J.L. Rancurel photothèque - Archive Photos - F. Garcia/Stills - A. Bizos/Vu - J.L. Rancurel photothèque
28 : Stills
29 : Roger Pic - Stills - Stills
30 : Pat/Stills
31 : Olivier Deschamps/Vu
32 : Archive Photos - J.L. Rancurel photothèque - Roger Parry/Ministère de la Culture - INA - Stills - Archive Photos
33 : © P. Delanoë - Archive Photos - J. Pimental/INA -

Archive Photos - J.L. Rancurel photothèque - J.L. Rancurel photothèque
34–35 : Keystone
36 : Keystone - J.L. Rancurel photothèque
37 : Archive Photos, 1947 - Éditions Choudens - Stills
38 : Coll. Jean-Loup Charmet, 1927 - Illus. Zig/Coll. Jean-Loup Charmet - Léonard de Selva/Tapabor - Coll. Jean-Loup Charmet - Coll. André Bernard - Coll. J.L. Rancurel
39 : Stills - Coll. J.L. Rancurel - Keystone, 1931
40 : Archive Photos - D. Fallot/INA, 1959 - Archive Photos
41 : Archive Photos - Roger Viollet - Stills
42 : J.L. Rancurel photothèque - E. Muller - Archive Photos - Archive Photos
43 : E. Muller
44 : Roger Viollet - D. Fallot/INA - L. Joyeux/INA - Archive Photos
45 : D. Fallot/INA - Gian-Carlo Botti/Stills - Ph. Bataillon/INA - Archive Photos
46 : Keystone - J.L. Rancurel photothèque - Archive Photos - J.L. Rancurel photothèque
47 : G. Landau/INA, 1956 - E. Muller - Roger Viollet - R. Kasparian/J.L. Rancurel photothèque
48 : Patrick Ullmann - Roger Viollet
49 : J.L. Rancurel photothèque - Archive Photos
50 : J.L. Rancurel photothèque
51 : J.L. Rancurel photothèque - Stills - J.L. Rancurel photothèque - J.L. Rancurel photothèque - J.L. Rancurel photothèque
52 : J.L. Rancurel photothèque
53 : J.L. Rancurel photothèque
54 : J.L. Rancurel photothèque - Pat/Stills - Coll. Christophe L
55 : Coll. Christophe L - C. Geral/Stills - Pat/Stills
56 : Archive Photos
56–57 : Archive Photos, 1965
57 : Archive Photos, 1951 - INA, 1962 - Archive Photos, 1948
58–59 : Coll. Christophe L
60 : Keystone, 1869 - Keystone, Londres 1935
61 : Coll. Christophe L - Éditions Raoul Breton - Archive Photos, 1955
62 : Keystone
63 : Keystone - Keystone - Archive Photos - Keystone - Stills

64 : R. de Valério, 1923/Coll. Jean-Loup Charmet - Coll. Jean-Charmet, 1935 - Ch. Kiffer/Coll. Jean-Loup Charmet
64–65 : Dessin Girard, 1937/Coll. Jean-Loup Charmet - Léonard de Selva/Tapabor
65 : Affiche Ch. Kiffer/Coll. Jean-Loup Charmet - Affiche G. Girbal/Coll. Jean-Loup Charmet - Coll. André Bernard
66 : J.L. Rancurel photothèque - E. Muller
67 : Archive Photos, 1949 - E. Muller - J.L. Rancurel photothèque
68 : Archive Photos - Archive Photos - Roger Viollet - Archive Photos
69 : Roger Viollet - Roger Viollet - Stills - Roger Viollet
70 : Archive Photos, Marseille 1968 - Ph. Bataillon/INA, 1958 - J.L. Rancurel photothèque - Archive Photos, 1957
71 : E. Muller - Archive Photos, Rome 1959
72 : Archive Photos, 1967 - Eric Bourret/Stills, Marseille 1985 - Archive Photos, Bobino 1965 - Archive Photos, Alhambra 1965
73 : Archive Photos, Bobino 1971 - Roger Viollet, Olympia 1963 - Roger Pic
74 : Claude Schwartz/Vu, 1961 - J.L. Rancurel photothèque - J.L. Rancurel photothèque, 1966 - Archive Photos, 1966 - INA, 1964
75 : J.L. Rancurel photothèque - J.L. Rancurel photothèque - Archive Photos
76 : G. Landau/INA - Stills - J.L. Rancurel photothèque - J.L. Rancurel photothèque - J.L. Rancurel photothèque
77 : J.L. Rancurel photothèque - INA - G. Galmiche/INA - J.L. Rancurel - J.L. Rancurel photothèque
78 : Eric Catarina/Stills - Pat/Stills - G. Houin/ J.L Rancurel photothèque
79 : J.C. Dupin/Stills
80–81 : Pascal Victor/Stills
82 : A. Courant/INA, 1964 - D. Fallot/INA, 1958 - Alain Bizos/Vu
83 : Ch. Prost/INA, 1951 - Éditions Raoul Breton
84 : Coll. André Bernard
85 : Léonard de Selva/Tapabor - Affiche Peynet, 1932/Coll. Jean-Loup Charmet - Coll. J.L. Rancurel
86 : J.L. Rancurel photothèque - R. Kasparian/ J.L. Rancurel photothèque - 1955, Doc. Stills - Poirier/Viollet, 1963 - INA, 1966 - Doc. Stills, 1955

87 : Patrick Ullmann
88 : Patrick Ullmann
89 : Patrick Ullmann - J.L. Rancurel photothèque - Patrick Ullmann
90 : People Express - Archive Photos, 1954 - Jacques Aubert/Barclay - Stills - J.L. Rancurel photothèque, 1966
91 : L. Joyeux/INA, 1965 - J.L. Rancurel photothèque - Ph. Bataillon/INA, 1962 - Allemane/INA, 1964 - J.L. Rancurel photothèque - Archive Photos
92 : D.R. - J.L. Rancurel photothèque - P.O. Deschamps/Vu - R. Kasparian/J.L. Rancurel photothèque
93 : G. Moreau/Lecœuvre/Rancurel - Eric Mulet/Métis - Virgin - Gérard Rondrau/Vu, 1989
94 : P.O. Deschamps/Vu - Eric Catarina/Stills, 1993 - Deluze-Arnal/Stills, 1993
95 : Pat/Stills, Bercy 1994 - Eric Catarina/Stills, 1994 - F. Camhi/Stills, 1987 - S. Arnal/Stills, 1988
96 : Lithographie Georges Bastia/Coll. Jean-Loup Charmet - Coll. M. Lallemand
96–97 : Keystone, 1966 - Archive Photos, 1959 - R. Kasparian/J.L. Rancurel photothèque
97 : DR. - André Bernard
98–99 : Gian-Carlo Botti/Stills
100 : Illus. Guy Arnoux/Coll. Jean-Loup Charmet - Illus. Clekice frères/Coll. Jean-Loup Charmet - Coll. André Bernard
101 : Éditions Raoul Breton - Stéphane Ragot
102 : J.L. Urli/Stills - R. Picard/INA, 1973 - Cl. James/INA, 1968 - J.C. Dupin/Stills
103 : J. Chevy/INA, 1975 - Patrick Ullmann - J.L. Rancurel photothèque, Bobino 1972
104 : Hernat/INA, 1965 - J.L. Rancurel photothèque - J.L. Rancurel photothèque - Gian-Carlo Botti/Stills
105 : Patrick Ullmann - Patrick Ullmann - J.L. Rancurel photothèque - J.L. Rancurel photothèque, ABC 1972
106 : Patrick Ullmann - Gian-Carlo Botti/Stills, 1965 - Archive Photos, 1959 - J.L. Rancurel photothèque
107 : J.L. Urli/Stills, 1983 - Patrick Ullmann - Patrick Ullmann - J.L. Rancurel photothèque - F. Courtés/Vu
108 : L. Legrix/J.L. Rancurel photothèque - Didier Gaillard/Virgin - Martine Voyeux/Métis - J.L. Rancurel photothèque
109 : J.L. Rancurel - J.L. Rancurel photothèque - Patrick Ullmann - Martine Voyeux/Métis